On Alexander Gardner's
Photographic Sketch Book
of the Civil War

Defining Moments in American Photography
Volume 1 of a series edited by Anthony W. Lee

On Alexander Gardner's
Photographic Sketch Book
of the Civil War

ANTHONY W. LEE

ELIZABETH YOUNG

Published with the assistance of The Getty Foundation

University of California Press

Berkeley Los Angeles London

The publisher gratefully acknowledges the generous contribution
to this book provided by the Art Endowment Fund of the
University of California Press Foundation, which is supported by
a major gift from the Ahmanson Foundation.

Contents

Introduction

ANTHONY W. LEE

WHEN ALEXANDER GARDNER's great *Photographic Sketch Book* of the Civil War was published in 1866—in two volumes of fifty photographs each, with text written by Gardner accompanying each image—it became famous in several ways.[1] First, although the *Sketch Book* was initially a commercial failure, by the end of Reconstruction it had become the best-known visual representation of the Civil War. Second, although other photographic books had been published before, notably British works, the *Photographic Sketch Book* became a foundational volume in the history of American photography, the first book to rely so heavily on pictures for its meanings. And third, disarticulated into its hundred parts, the book became famous for individual photographs, which circulated separately and widely and sometimes eclipsed the book itself. Such pictures as *A Harvest of Death* (no. 36 in the *Photographic Sketch Book*) and *Home of a Rebel Sharpshooter* (no. 41) became and still remain iconic representations of the dead soldiers at Gettysburg. In these many ways, the *Photographic Sketch Book* helped define how viewers, then and in subsequent generations, came to know the Civil War.

Yet, as most observers now recognize, the *Photographic Sketch Book* is a highly selective account of that war. In this volume, we point to places where Gardner's choices can be glimpsed and explore how we can understand both the logic behind his selections and their partisan nature. As our starting point,

we take seriously that the *Photographic Sketch Book* is made of not only images but also words. The book partakes of at least two histories and contexts—visual and literary—and belongs to the many understandings and possibilities accorded to both in the mid–nineteenth century. We assess the book in relation to its photographic and literary times and ask how it tried to address, through its marshaling or manipulation of visual and literary forms, the drama of the Civil War. In particular, we consider that aspect of the book whose presentation of the war's meanings was arguably most controversial in 1866: its representation of the African American experience and the subjects, as suggested in *What Do I Want, John Henry?* (no. 27 in the *Sketch Book*, figure 1 in our volume), of slavery and emancipation.

We do not always agree what the best means of deciphering should be—the first essay is written from an art historian's perspective, the second a literary scholar's—and we enlist different skills in interpreting the same book. At certain places, we mark our differences and allow the reader to judge our individual merits. For example, we each consider *A Burial Party, Cold Harbor, Va.* (no. 94; figure 2)—it is a defining moment in a book that is a defining work—but we reach different conclusions about it. As another example, we interpret the "sketch book" of the book's title in contrary ways and measure how these interpretations ought to be applied to an overall understanding, the art historian viewing it in a narrower visual sense, as in an "artist's sketch book," the literary scholar in a wider sense, to include literary "sketches." But despite our differences, or indeed because of them, our shared goal is to take seriously the hybrid nature of the book and to suggest how reviewing, in turn, images and words can provide special insight into the book's complex meanings, especially as they relate to questions surrounding race and race relations.

For a book that is so famous, relatively little has been written about the *Photographic Sketch Book* as a self-contained and expressive work.[2] Some of this hesitation may be attributable to our lack of information about Gardner himself and how he came to produce such an extraordinary thing. What little

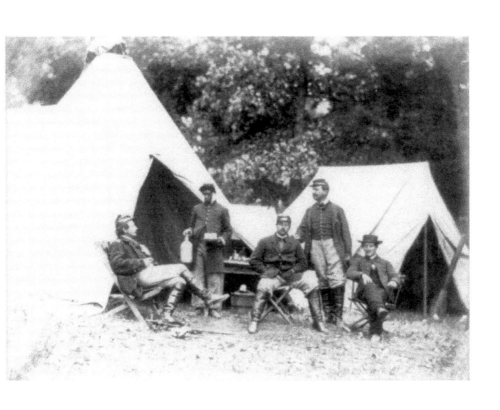

Figure 1 Alexander Gardner, *What Do I Want, John Henry?* (no. 27 in the *Photographic Sketch Book*), 1862. Courtesy of the Library of Congress.

Figure 2 Alexander Gardner, *A Burial Party, Cold Harbor, Va.* (no. 94 in the *Photographic Sketch Book*), 1865. Courtesy of the Library of Congress.

is known can be summarized quite briefly. He was born in 1821 in Paisley, Scotland, and early on tried out various careers—jewelry making, journalism, and banking. As a young man, he seems to have been influenced by British socialism, profoundly enough that in the 1840s he was planning and underwriting a utopian colony of Scottish settlers in Iowa. The colony was founded with his brother and brother-in-law in the lead, but it lasted only a few years. Gardner himself never took part in the actual settlement. How he came to photography is unclear. In 1851, he may have seen early examples of it in London at the great Crystal Palace Exhibition, which included the work of the British photographer Roger Fenton and his scenes from the Crimean War; but while the London exhibition was the major cultural event of its times, visited by tens of thousands from across the British Isles, we have no concrete evidence suggesting that Gardner himself attended. Whatever the circumstances of his exposure, by 1855 Gardner had abandoned all of his previous professional ventures and was operating a photography studio in Dumbarton. The studio was short-lived. A year later, he and his family left Scotland altogether, immigrating to New York and starting a new life.

Almost immediately upon his arrival in New York, Gardner became an assistant to perhaps the most famous American photographer of the day, Mathew Brady. He quickly became Brady's key assistant, usually credited with straightening out Brady's slipshod books, introducing large-format photographs (the velvety "Imperial" photographs for which Brady soon became noted), and opening and running Brady's new Washington, D.C., office. While Brady devoted himself less and less to actual camerawork, Gardner assumed more and more the hands-on, day-to-day business of being a photographer. He helped to cultivate Brady's Washington gallery as an important locale, one of the preferred studios for the capital's politicians and celebrities. By the outbreak of the war in 1861, Gardner, an immigrant who had been in America barely more than five years, found himself in a prime position to make pictures of the country's most traumatic event. He continued as Brady's assistant until late 1862; at that time he struck out on his own, opening a competitive studio in Washington,

taking Brady's most accomplished photographers with him, and publishing thousands of individual Civil War pictures under his new studio's imprint, many under the serial title "Photographic Incidents of the War." By the war's end, he had amassed and marketed more than three thousand pictures.

Exactly when Gardner decided to compile a select few photographs into a book is unknown, but it was probably in the latter part of 1865, just a few months after the war's end. He clearly meant the book as a luxury item. Each photograph was printed and mounted separately; each was titled and properly dated; each was carefully attributed to the photographer who had taken it (any one of Gardner's many assistants) and the photographer who printed it (invariably Gardner himself); each was accompanied by long text or "letter-press," as he sometimes called it; each letterpress was printed and set separately; and the individual leaves, at the time known as large imperial elongated quartos, were bound together in an expensive brown morocco wrapper. Gardner priced the whole thing at $150—an astronomical price that very few could easily afford—and made no more than 200 copies. Although the book comprised two volumes, it was offered as one large work; there is no evidence that the volumes were ever divided and sold separately.

The basic outline of the *Photographic Sketch Book* is relatively clear. The book begins and ends with scenes related to death. The first, a view of the Marshall House in Alexandria, Virginia, marks the spot where Elmer Ellsworth, a young, dashing, and popular colonel from New York, was shot and killed, the first Union martyr of the war. The last, a view of a crowd at the dedication of a monument for the Union soldiers killed at the first battle of Bull Run, marks an ending of sorts; it was taken in June 1865, after the fighting had stopped. The first marks an individual sacrifice, the last a mass death; the first an instant precipitating violence, the last laying it to rest. In between are scenes that refer, usually indirectly, to the progress of the four-year war. They are roughly grouped by the various campaigns undertaken by the Union's Army of the Potomac. In volume 1, for example, a series of pictures related to the 1862 Battle of Antietam and its aftermath comes before a series related to

the Union assault later that year at Fredericksburg; there follow the famous scenes of the dead at the next summer's gruesome, climactic turning point at Gettysburg. In volume 2, photographs trace the winding and yet inexorable Union march to Petersburg and Richmond and, finally, Robert E. Lee's surrender to Ulysses S. Grant at McLean's House in Appomattox.

But of course, for the reader, the questions quickly emerge: Why this outline and not another? Why these photographs and not others? How do the pictures work together? How do the words fit with the pictures and each other? What issues of the war do they highlight, and what is their attitude or argument about them? The *Photographic Sketch Book* does not measure or meditate openly on its meanings. The essays that follow do.

The Image of War

Anthony W. Lee

TO AN ART HISTORIAN, the defining quality of Gardner's *Photographic Sketch Book* has much to do with its foundational status in the use of pictures to tell a story.[1] Equally important, it has much to do with an embrace of what a camera could—and, especially, could not—do in visualizing such a momentous and complicated thing as war, showing how these constraints were not impediments but instead could be manipulated into a central means of description. Whatever can be gleaned of Gardner's partisanship was bound up in the camera's peculiar qualities; it could not offer a summary of the Civil War, despite the intense desire of his contemporaries to do so. Yet, as I'll argue, it was Gardner's considerable achievement to have found something in photography's values that could match the disruptive, disjointed, and retrospective experience of war. In this sense, it was also Gardner's achievement to have produced for the first time in the history of American photography a collection of pictures—cleaved, piecemeal, and self-conscious of their means: a distinctly modern work.

To discover these aspects, I want to return Gardner to some of the debates, pressures, and opportunities facing Civil War photographers—to return him, I hope not unreasonably, to the daily world of his work. I will emphasize his relationship not only to photography as a profession but also to the efforts of other image makers, especially magazine illustrators, and of popular historians

who used images. And I'll end with a brief consideration of his representation of African Americans and how his understanding of them can be seen as of a piece with his understanding of the camera. Gardner, it will become clear, was not magically whisked away from the concerns of a larger visual culture when he tracked the Army of the Potomac, and he was certainly not alone in the field, somehow apart from the many others who were busy gathering images and assessing the war. But the newness and strangeness of such a project to visualize conflict gave these men a different access to it.

WHAT DID IT MEAN to be a photographer in the 1860s, and how did this meaning inform the *Photographic Sketch Book*'s ambitions? Beginning in the mid-1850s, photographers were finally shaking off something of the lowly, charlatan, fly-by-night reputation that many of their predecessors had notoriously obtained. Plenty of fumbling operators still dotted the landscape, reminding everyone just how amateurish, hoodwinking, and disreputable the field had once been. But there was increasingly a move to professionalize it, to give photography the kind of stature and institutional weight enjoyed by other artisanal practices, including the publication of the field's first journals, the assembly of its first national organizations, the call for its first schools, and even its embroilment in complicated issues related to patents and copyright.[2] In some respects, the Civil War accelerated the process of professionalizing, since it brought a few lucky photographers in contact with the big publishing houses and the national magazines as never before. But in other respects, the war allowed photography's fly-by-night character to linger, as it seemed to place easy money within reach of hordes of lowly cameramen.

Such lingering is most notable in portraiture, which constituted by far the bulk of Civil War photography. It seemed as if nearly every one of the 3 million soldiers who took part in the war wanted a carte de visite or tintype portrait of himself. They dressed in their fine new uniforms, polished their buckles and buttons, dusted off their shoes, crooked their hats just so, and visited the photographer. The photographers, most of whom operated small, single-man

studios and struggled to turn a profit, set themselves up to meet these men in their finery. Doing so required not a transformation but simply an expansion of their workload before the war: their bread and butter had always consisted of portraits of common folks in cities and small towns. For the itinerant operator, the new demand meant doggedly tracking the armies, tacking up a cloth backdrop when he caught them in camp, setting up a makeshift darkroom, and converting the cramped supply wagon that usually doubled as a bed into a sales tent. Because each sitting brought between one and five dollars, there was huge money to be made.

While portraiture was well established, the landscape view, in the form of a stereoview or album card, was just coming into its own. This new face of photography was a riskier venture, attempted by only the more established photographers. It cost more—a photographer had to buy another camera, a fancy double-mounted setup, and an entirely different supply of papers and cardstock. In contrast to a portrait, which had a built-in buyer, it was speculative—pictures of the local environs were taken for an audience that might never materialize. And it required marketing and smart distribution— the views needed to be assembled into lists, packaged as touristic snippets, and advertised widely; some ambitious photographers put them into the hands of salesmen. Portraiture allowed the old character of photography to persist, but the view demanded something new; even more, it required that the business be conceived as a little cottage industry. For a photographer to undertake it successfully, he had to involve himself in the field's large developments, casting a wider social and professional net and thinking in more national terms.

There is ample evidence to suggest that Gardner fell on the side of the new. He became an early member of the National Photographic Association, kept his ties with the American Photographical Society, took part in national debates to protect the rights of photographers, and displayed his pictures in many of the new, eye-catching exhibitions. He made sure to copyright nearly all of his published views (a practice most operators were clueless about or simply ignored) and announced the copyright on his stereoviews and album cards.

He distinguished between the maker and publisher of photographs, as the *Photographic Sketch Book* makes clear for each plate ("negative by so-and-so, positive by Gardner"), in keeping with the growing legal distinctions and protections carved out for them. When he went on expeditions with the Army of the Potomac, he went in search of views and anticipated they would form part of a larger set, meant for wide distribution.

Today, some photography historians view Gardner as exceptional in his willingness to invest in views and travel with the armies to obtain them. But he was certainly not alone. The new character of photography encouraged many ambitious men to think in these broad terms. G. H. Houghton traveled even farther than Gardner, leaving his home in Brattleboro, Vermont, in 1862 to make pictures of the Army of the Potomac's Peninsula Campaign in southeastern Virginia; Henry Moore of Concord, New Hampshire, left that same year to follow a regiment of New Hampshire troops all the way to the Carolinas, where he took their portraits and also views of the local scenery. How these men obtained supplies is unknown—it might have required scrounging or some knavery—but the money from the soldiers and stereo distributors must have been good enough to outweigh these difficulties. At one time or another, nearly three hundred photographers hooked on with the Army of the Potomac.[3] In addition to these roving operators, many small and now mostly forgotten photographers made views of the war when the armies came within their environs. At Gettysburg, for example, besides the more famous Gardner, Mathew Brady, James Gibson, and Timothy O'Sullivan, at least ten other photographers took pictures of what, for them, were local scenes.[4]

But though Gardner's ambitions and wherewithal had a new flavor to them, they also carried a whiff of the old. He kept a portrait studio, outfitting it as most operators did—complete with the placards and banners offering every kind of newfangled image (figure 3)—and derived a healthy business from it. Such places couldn't quite shake an element of hucksterism, signaled by the Barnum-like loudness and self-promotion that Gardner, like photographers everywhere, had adopted. The introduction in the mid-1850s of the wet-plate

Figure 3 Alexander Gardner, *Gardner's Gallery, Corner of 7th and D Streets, Washington, D.C.,* ca. 1863. Courtesy of the Library of Congress.

process, by which a single negative could yield countless positive prints, had given rise to an enormous explosion of cameramen: the idea of making a quick dollar became a lure for many who had never previously picked up a tripod and lens. The speculators seemingly appeared out of thin air and, suddenly countless in number, competed ferociously with each other for business. Gardner had no choice but to blare as loudly.

This transitional moment in photography was the professional setting for the *Photographic Sketch Book*. It helps explain the preponderance throughout the book's pages of the view over the more ubiquitous portrait, even though the magazines and papers covering the war traded in a cult of personality and Gardner had a healthy stock of images of generals and politicians. It also helps us see how the book resembles his many stereoview lists, as opposed to his celebrity portraits, also pitched for sale to a general audience. He was imagining the *Photographic Sketch Book* as a compendium of places, not people, of views, not portraits; and he was banking on the keen new interest in stereoviews and the like to guarantee its welcome. At the same time, he was distinguishing himself from his major competitor and former employer, Mathew Brady, who had previously made a reputation for himself with a portrait compendium, his *Gallery of Illustrious Americans* (1850).

Gardner's insistence on the view is most noticeable in the few places where portraits do appear—especially the appearance of perhaps the most important and controversial figure presiding over the war, the president himself. By the time Gardner began assembling the book, Lincoln was already dead and in the process of being transformed into an even greater cult figure. Gardner had done much to facilitate that transformation, distributing widely his famous portraits of Lincoln (figure 4) and making pictures of Ford's Theater, where the president had been shot; more pictures of the house where he had later died; and portraits of the conspirators, the prison where they had been held, images of their execution, and on and on. Yet neither those many photographs nor even the mention of Lincoln's death appears in the *Photographic Sketch Book*. Gardner opted instead for an upright, formal portrait of Lincoln during a visit

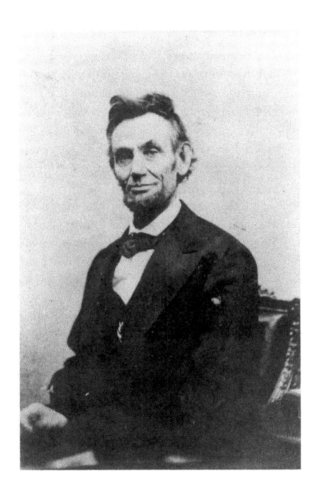

Figure 4 Alexander Gardner, *Abraham Lincoln,* 1865. Courtesy of the Library of Congress.

to George McClellan in the field (no. 23 in the *Sketch Book;* figure 5), not the quieter tête-à-tête between the president and the general he had also pictured, and certainly not the intimate studio portraits that had become so cherished. It is an ungainly picture, a spread of figures against a makeshift camp scene—the men in a stiff choreography so like common studio pictures, as if they all were standing with the ubiquitous neck braces amid the bright and airy spaces of the field. We need only compare it to other group scenes, like *What Do I Want, John Henry?* (no. 27; see figure 1), to recognize its rigid and awkward effect.

On the one hand, the choice was a refusal or repression of Lincoln's death as part of the war, or perhaps reflected a belief that the man was best portrayed as an active, upright participant in that drama. But on the other hand, it is of a piece with other instances of portraiture, even of the most famous sitters, throughout the entire book: they appear only in the context of the view, no matter how awkward the mixture came out. The *Photographic Sketch Book* represented a new venture in that Gardner, a photographer with a sense of recent trends in camera work and his place within them, wanted to visualize the war and make that visualization central to its telling. The view was the new mode and carried a professional meaning—more institutional, more weighty, more national, more legitimate—as the photographer tried to make a place for his craft.

WHEN GARDNER AND HIS ASSISTANTS took to the road to get views of the war, they had a great deal of company. There had never been a war so well covered by sketch artists, illustrators, and photographers as the Civil War.[5] Among the artists, Winslow Homer may now be the most famous of the lot, but he was by no means the only one in the field.[6] When three New York magazines—*Frank Leslie's, Harper's Weekly,* and the *New York Illustrated News*—opened shop in the 1850s, they distinguished themselves from other papers by including lavish illustrations in their pages. These were wood engravings based on the drawings of sketch artists—"Special Artists" or "Specials," as they were

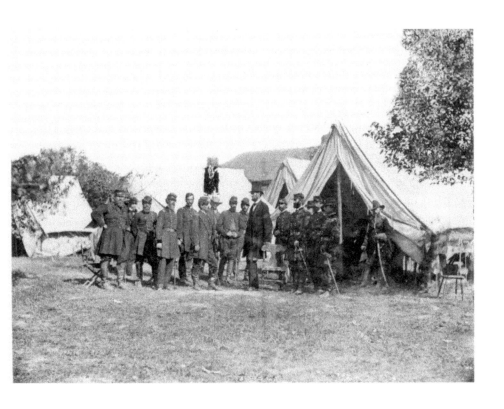

Figure 5 Alexander Gardner, *President Lincoln on Battle-Field of Antietam* (no. 23 in the *Photographic Sketch Book*), 1862. Courtesy of the Library of Congress.

often called—whose work on the streets and in the fields brought vividness and immediacy to news coverage. Depending on how long a sketch took to reach an editor's desk, the papers promised that a drawing made in the field one day could end up as an engraved and published illustration within two or three weeks, easily considered newsworthy for an American audience. The first of their kind, the papers quickly won a national readership.

When war began in 1861, all three magazines almost immediately sent artists on assignments; some camped with the troops and followed them into battle, while others raced back and forth between various maneuvers, galloping at breakneck speed when they received word of a battle about to commence somewhere within riding distance. (The artists were all Northerners working for a Northern clientele; the South had no comparable array of artists or publications.) They attached themselves to Union commanders and learned about troop movements, embedding themselves in this corps or that regiment, all the while living in the war theater and only occasionally returning to the main office. Sketches were sent back by any means possible—by mail, in the hands of friends who happened to be heading off in the right direction, via courier services. They filled the papers with images of life in the camps, during the march, on the attack, on the picket line, or in the trenches. Over the course of the war, nearly six thousand images of one form or another were produced, appearing so regularly in the magazines as to constitute what one art historian has called "a moving picture of the War in its every phase."[7]

The image maker's livelihood depended on insider knowledge. The great Alfred Waud, who sketched for *Harper's* and the *New York Illustrated News,* was lauded by his admiring (and jealous) contemporaries for having "been in every advance, in every retreat, in every battle, and almost in every reconnaissance [and having known] more about the several campaigns, the rights and wrongs of several fights, the merits and demerits of the commanders than two out of three wearers of generals' shoulder-straps."[8] The praise was effusive but not without truth. Waud was seemingly everywhere at the right time—at the first Bull Run in 1861 and with George McClellan in the 1862

peninsular campaign; at Antietam and Fredericksburg later in 1862; at Chancellorsville and Gettysburg in 1863; at Wilderness, Cold Harbor, and Petersburg in 1864; and with Sheridan in the Shenandoah Valley campaign. He was even in attendance when Lee surrendered to Grant at Appomattox. His brother William, who sketched for all three magazines, spent just as much time on the move; he was at Fort Sumter in Charleston when the first volley of the war was shot, with Farragut in New Orleans in 1862 and later that year at Malvern Hill, present at the siege at Petersburg in 1864, and with William Tecumseh Sherman in his crushing, scorched-earth marches in 1864–65 through Georgia and the Carolinas. They traveled immense distances to get images. Theodore Davis of *Harper's* repeatedly zigzagged back and forth between the East Coast and the Mississippi River, each round-trip a thousand-mile journey by train and on horseback that even the armies were loath to make.

The sketch artists' energies and efforts throughout the Civil War throw a helpful light on Gardner's work in the field. In seeking to cover the war, Gardner and Mathew Brady resembled other enterprising journalists, editors, publishers, and illustrators, as the desire for pictures sent all kinds of image makers scurrying to the front. They loaded their various supplies—for the photographer, cameras, glass plates, chemicals, and tripods, all stuffed into a horse-drawn wagon—and joined a veritable army of special artists monitoring and following the troops. Some photographers, such as A. J. Russell and George Barnard, ended up working for the magazines. Gardner's celebrated relationship with the Army of the Potomac was unusual in its intensity—he called himself the "Photographer to the Army of the Potomac" and was said to have photographed maps for the army's U.S. Topographical Engineers and later for Generals McClellan and Burnside[9]—but not in kind. The Waud brothers, Davis, Edwin Forbes, Joseph Becker, Henri Lovie, Arthur Lumley, and countless others, most of whose names remain unknown, were doing much the same thing.

These many image makers constituted a shadow army, tracking the move-

ments and picturing the activities of the regular forces. They could sometimes be downright nuisances; Union commanders (Sherman, most notoriously) frequently tried to deter them for fear that their pictures might unwittingly provide information to the enemy. But they were more often a welcome part of the caravan that straggled behind the vast armies. The image makers certainly knew each other, sometimes picturing each other at work (figure 6; note the panel at left). On one level, they were competitors. Although the magazines generally used an artist's sketch as the basis for their engravings, they happily borrowed a photographer's picture, too, when it was particularly vivid, as *Harper's Weekly* did with several of Gardner's Antietam pictures. For their part, photographers knew of the sketch artists' results because the magazines with the finished illustrations were distributed not only in cities and towns but also in army camps and the fields, as the cameras were careful to record. On another level, photographers and sketch artists had much in common and often developed a social and professional camaraderie. They were young, mostly in their 20s or 30s (at 39 when war broke out, Gardner was one of the oldest). In the movable camps, they were responsible for their own tents, water, and meals ("hard ship bisquit" and even "harder salt tongue," as one of them complained);[10] if they could, they tended to huddle together and pool their resources. They lived with but also at a significant remove from the main troops and got no special security from them; their forays outside the camps and sentry lines were unprotected. (Gardner, like several of the sketch artists, was once captured by Confederates.)[11] Unlike the heavily encumbered armies, they tried to travel as lightly as possible; the photographers had to lug their heavy supplies but carried no more than was absolutely necessary, while the sketch artists had only their pencils and sketchbooks, field glasses, a blanket, a rubber poncho, and in winter a heavy coat. Although tied to a publisher and responsible for communicating with their main offices, they usually operated independently with a certain freedom of movement. They could, if they chose, pack their bags and break camp in pursuit of a tip. Because being on the spot mattered, they monitored each other in both competitive and friendly ways, and

Figure 6 Arthur Lumley, *Nine Camp Scenes*, 1862. Courtesy of the Library of Congress.

as a group they took the pulse of the latest developments coming over the wire or from inside the command tent.

Of course there were differences between photographers and sketch artists, in large part reflecting their different disciplines. The latest technology of photography, the wet collodion or wet-plate process, tied the photographer to a laborious set of procedures any time he wanted to take a picture. Each glass plate on which he wished to secure a usable negative had to be coated with a syrupy mixture of gun cotton, ether, and bromide and then bathed in a silver nitrate solution; the photographer had to tilt and angle each plate to make the syrup flow and spread evenly across the glass surface. To prevent exposure of the light-sensitive plate, he performed all these chemical gymnastics in the dark, in either a makeshift tent or his trusty wagon. He then put the prepared plate in a thick plate holder, and if he was lucky and the outside temperature was not miserably hot and the humidity level not exceedingly high, he had about ten minutes to rush to his camera and tripod (set up immediately before beginning the process), insert the plate, and expose it. He had an equal amount of time and even more complicated procedures to follow in order to develop the plate, fix the image, and rinse and dry the precious negative afterward. And then the whole process began again. In experienced hands, a single, usable picture took thirty minutes to obtain. Working in teams, as Gardner often did, sometimes made the process a little faster, but not much. It took five long days for Gardner and Gibson to make about seventy pictures at Antietam, an average of one every thirty or forty minutes during the best daylight hours.[12] Even when conditions were ideal, mishaps—cracked plates, under- or overexposure, uneven coating, incomplete rinsing—happened all the time. There was rarely 100 percent yield on any shoot. Good field photographers were hard to find. Unlike his competitor Brady, Gardner made sure to keep most of his best hands—Gibson, O'Sullivan, William Pywell, John Reekie, David Knox, William Frank Brown, his brother James Gardner—with him throughout the war. Only George Barnard struck out on his own, foraging farther south and eventually producing a competitive photographic album of an arena for which Gardner had no images.[13]

These labor-intensive procedures meant the photographer was fettered by his equipment and, especially, his makeshift darkroom, whereas the sketch artist could roam about freely. The artist could work on several sketches at once, simply going back and forth between sheets of paper on his pad; the photographer, in contrast, concentrated on one image at a time. And while the artist could travel for weeks on end with a regiment, chasing a lead or following his nose, the photographer had always to be aware of his distance from his home base and his precious supplies. These differences added up to different kinds of coverage. In the first place, the special artists had broader range and, in terms of geography, covered more of the war. They could be found almost everywhere there were troops and conflict, including the distant but important western theater. Photographers focused almost entirely on developments on the East Coast, within reach of the major chemical and glass plate suppliers in New York and Philadelphia. Huge portions of the war—the dramatic events at Vicksburg, for example, or the opening strike at Fort Sumter, or nearly anything along the whole length of the Mississippi River—had no photographs made of them by the national studios. Gardner's coverage of the Army of the Potomac was savvy, as he followed one of the most important fighting units and was in the environs of some of the war's major battles; but it was also strategic, for he was rarely more than a day's ride from his studio and extra equipment. His decision to stay close to his base is the single reason the geographic spread of the *Photographic Sketch Book* is so limited. He rarely tried to send his teams far away to cover events, no matter how compelling or important they may have seemed. During the last year and a half of the war, Gardner chose to stay primarily in his Washington studio, rather than march with the troops, and he forayed quickly in his wagon to battle sites when news of a clash reached him.

But the differences went beyond geographic scope. Photographers and sketch artists developed distinctive approaches to what and how to picture, and for what purposes. Take, for example, an on-the-spot drawing by Edwin Forbes, *The Charge across the Burnside Bridge at the Battle of Antietam, September 17, 1862*

(figure 7). In the quick notations of landscape and figures and in the mad dash to get a scene on paper, it suggests something of the sketch artist's habits. In the midst of battle, Forbes, like nearly all sketch artists, usually sought high ground where he could obtain good views (and could hope to avoid being shot). From these vantages, he first noted the site's peculiar contours and details— a bridge here, a line of trees there, a stone fence running this way, a house sitting that way. The goal was not completeness but enough annotations about what made a site particular and recognizable. The rest could be filled in later. Then he jotted down the dispositions and movements of troops. These, too, were approximations; soldiers would be drawn no more distinctly than thick stick figures, sometimes merely as dark silhouettes or as a series of heavy hatchings, and perhaps a shadow or two here and there would be included to provide a sense of their scale and distance from each other. Abbreviation was the key: a single stick figure in the sketchpad could represent a dozen or more men in the field. Some figures might be upright and running, others fallen, and still others huddled behind trees or walls; each one could represent a whole corps. The scant details of such a sketch were enough; the artist had to turn the page and quickly begin another picture.

When he had time after the battle, the artist began filling in; and to help with the task, he turned to a handy reference notepad he had already assembled in camp. The filling-in process entailed not merely crowding the empty spaces or multiplying the figures in the rough drawing but supplying as much detail as possible. In his notepad, the artist kept "memorandum sketches" of the troops and all their accoutrements. "Infantry, cavalry, and artillery soldiers, each had their particular uniform," *Harper's* Theodore Davis explained, "and besides these, their equipments, such as belts, swords, guns, cartridge-boxes, and many other things, were different. Their tactics and maneuvers were not alike, and some distinguishing point in each uniform designated the corporals, sergeants, lieutenants, captains, majors, colonels, and generals[;] . . . there was a great variety."[14] The combination of on-the-spot drawing and memorandum details provided a certain vividness and graphic richness that the magazines

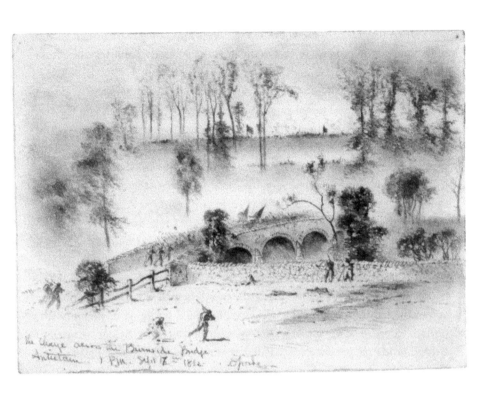

Figure 7 Edwin Forbes, *The Charge across the Burnside Bridge at the Battle of Antietam, September 17, 1862,* 1862. Courtesy of the Library of Congress.

could then use. Of course, what the engravers and popular printmakers did with the drawings back in the main office was another matter altogether (figure 8).

Thus the logic of the sketch artist's work fell somewhere on the spectrum between notation and memorandum, between the quick sketch and the catalogue of references, and his goal (or the effect) was the immediacy and specificity of an eyewitness; but the photographer developed other habits, conditioned by the nature of his craft. Compare Forbes's drawing to Gardner's photograph of the same site, his *Burnside Bridge, across Antietam Creek* (no. 20; figure 9). Gardner arrived at Antietam from his Washington studio on either the final day of the battle or the day after it ended—in any case, so soon after the engagement that the bodies of the dead had not yet been buried.[15] It was his first effort trying to picture a battlefield. But despite his rush—riding at breakneck speed from Washington, uncharacteristically not bothering to take any pictures along the way—he was still too late to observe any of the fighting. Guided by witnesses, he opted for views of the most important sites, making picture after picture of Burnside Bridge, Antietam Bridge, and the grassy and wooded regions around them. Compared to Forbes's drawing or the more fully developed, fanciful illustration in *Frank Leslie's,* the photographs all seem so empty of incident, merely registering places of historical interest.

Furthermore—and this is the most important point—as much as Gardner's pictures are descriptions of key sites, they are also about an effort at imaginative recovery and, even more, prodigious attempts to signal an action nowhere present. "And here is the Burnside Bridge!" the photograph seems to declare. "Here is where the Ninth Corps charged and fell!" "And here is the bridge again, from the southeast," another one says. "And here it is again, from farther downstream!" "And now we see it from a bird's-eye perspective!" Gardner took a dozen pictures of the empty bridges, six to seven hours of his time at the battle site, almost a quarter of his entire shoot. Why? "It was at this point that some of the most desperate fighting of the battle of Antietam occurred,"

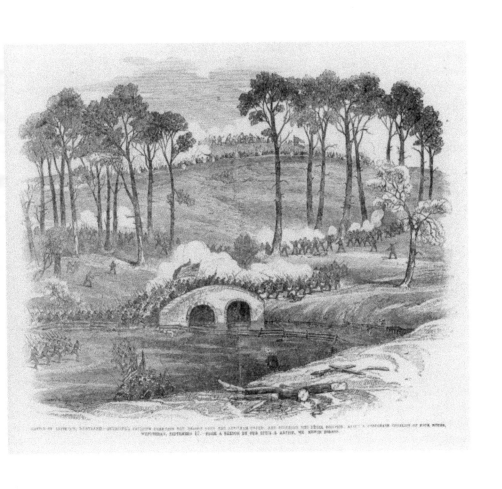

Figure 8 Unknown artist, *Battle of Antietam, Maryland–Burnside's Division Carrying the Bridge over the Antietam Creek and Storming the Confederate Position, after a Desperate Conflict of Four Hours, Wednesday, September 17th, 1862,* 1862. Courtesy of the Library of Congress.

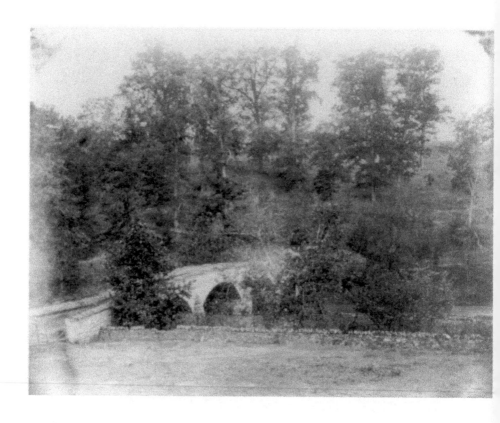

Figure 9 Alexander Gardner, *Burnside Bridge, across Antietam Creek, Md.* (no. 20 in the *Photographic Sketch Book*), 1862. Courtesy of the Library of Congress.

he wrote in the accompanying letterpress. But in all the emphases implicit in the photographs and explicit in the text, the many scenes and points of view could show only the photographs' belatedness. The desperate fighting was nowhere apparent and, given the laborious nature of camerawork, never would be. The soldiers were back at camp or on the run, others were burying their fallen comrades, and industrious sketch artists like Forbes were busy in their tents putting the finishing memorandum touches on their drawings to send to the papers. As if to accentuate both the imaginative effort and the belatedness of his scenes, Gardner took a picture of a picnic party of ladies and their escorts, who with their lunches were out for an afternoon's trip and, like Gardner, from the safety and distance of time were trying to review the battle site (figure 10). He and they had the bridge to themselves.

We might be tempted to regard Gardner's photographs as somehow lesser representations than those offered by the sketch artists, particularly given the new stress on capturing the rush and frenzy of combat. But that would be a mistake. He was competing, sometimes mightily, with the sketch artist's craft but not replicating it. He learned instead to explore what he could and could not acquire with his camera. The bridges and, especially, the stilled, fallen bodies at Antietam showed him his range and, equally important, where his effectiveness and uniqueness might reside within a universe of so many other kinds of visual examples. To name again some of the distinguishing features of his craft: the camera pictured not events but instead only the sites and remains of events already passed; it registered, mostly by implication and imaginative reconstruction (and through the services of the letterpress), the marks of history; and it everywhere betrayed its own belatedness.

Today, those aspects of photography are familiar. The quality of belonging to a frozen but already passed moment; the "that-has-been" of pictures; the paradox of the simultaneous presence and absence of a subject (a portrait of a sitter who is no longer alive, for example); the strong, sometimes eerie suggestions of loss and, related to that, of melancholy and mourning—these are recognizable features of early photography and inform much of our theory of

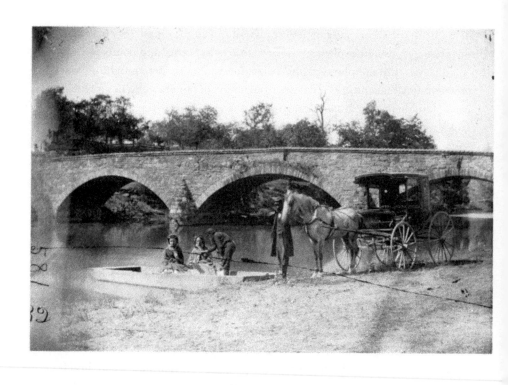

Figure 10 Alexander Gardner, *Pic-nic Party at Antietam Bridge, 22nd September, 1862*, 1862. Courtesy of the Library of Congress.

it.[16] The *Photographic Sketch Book* represents a founding and defining moment when these important and now widely recognized characteristics of photography were first in evidence and being explored. The difference was that in the *Photographic Sketch Book,* unlike a portrait of a sitter no longer alive, the soldiers in many of the pictures are literally absent. (Of the one hundred images, more than a third picture no people at all; in the rest, the tiny figures are usually dwarfed by the "view.") What is emphasized is the stage that once held them, as if the photograph, like the sketch artist's draft, made notations of the place but did not fill in memorandum details that gave identities to the men. Perhaps the photographer's confrontation with death helped trigger this sensibility, but it is equally the case that it grew out of the restrictions of camerawork in the war theater. For photographs are like corpses insofar as they are representations of past or even lost things—dead things, as Gardner came to know—and the melancholy they trigger in us is related to our inability to hear or touch or smell anymore; we can only see, very provisionally, the ghostly things within them.[17]

Time and again, in the letterpresses throughout the *Photographic Sketch Book*, Gardner emphasizes these many qualities, no matter the kind of scene being offered. "Such pictures carry one into the very life of camp," he writes of a scene near Cumberland Landing, "and are particularly interesting now that that life has almost passed away." "[G]raves, half hidden by the grass, tell where the dead of both armies slumber," he notes of another near Centreville, "and the spot now only interests visitors because of the wreck that has come upon it." "Its recollections are treasured among the happiest memories of the field," he observes of a makeshift bower. "Precious are the memories of its bivouacs," he says of a photograph of a camp. "What sad reflections crowd upon the mind in visiting these relics of the past!" (nos. 16, 4, 57, 60, 63). In nearly all cases, the documentary or evidentiary nature of photographs is coupled with some registration of their pastness, the scene perceived as once full but now somehow hollowed.

That is to say, while most observers today agree that Gardner's pictures were

partial—partial in their coverage, partisan in their attitude—their partiality can be usefully understood, especially in comparison to the habits of other visual artists, by way of the camera's special requirements. Furthermore, while the camera imposed limitations, it also offered new possibilities; and Gardner, an image maker among image makers in the battlefield, found in the unique aspects of photography a different and potentially promising vantage for describing the war.

GARDNER WAS NOT ALONE in his idea to assemble pictures and match them with written texts. As early as 1861, mere months after the cannons had first fired, popular historians began doing much the same thing. That year, Orville Victor published a two-volume set with the authoritative title *The History, Civil, Political and Military, of the Southern Rebellion, from Its Incipient Stages to Its Close.* Although the war was far from over, Victor declared that his work, ending with the anticipated launch of the battleship *Monitor* in early 1862 and the utter irresolution of the conflict, "shall cover the entire subject."[18] Its sales were sensational. In addition to a blow-by-blow recounting of events, he included transcriptions of congressional debates, documents exposing secession plots, Lincoln's stern letters to Congress and to Southern politicians, maps of battle plans, even a "secret history" of the inept Buchanan administration, and, most important for our purposes, engravings derived from drawings and photographs. Portraits of politicians and military commanders—Lincoln, Andrew Johnson, the bloated and grizzled Winfield Scott, and others—were based on photographs (from the looks of them, Mathew Brady's prints, though the source is never named) and make up the bulk of images; but there are scenes devoted to battles that originated in fanciful artists' renderings. The rhythm of images and texts followed on the model of many antebellum publications: a few engraved plates inserted as single pages into a welter of text. It helped establish the role played by images—like the maps and documentary appendixes, they were part of the supporting apparatus—and opened the floodgates for more publishing ventures.

The publications came tumbling out. In 1862, *Frank Leslie's* released a picture book made up of the many engravings the magazine had published since the war's beginning.[19] In contrast to books like Victor's, it reversed the proportion of image and text, allowing pictures to carry the burden of description. In addition, it introduced for the first time the hybrid field sketch—the notation and memorandum drawing produced by the special artists—which became the central kind of image in the book, displacing the hitherto more common portrait of the military commander. In 1866, the year that the *Photographic Sketch Book* appeared, J. T. Headley published *The Great Rebellion,* John Abbott his two-volume *The History of the Civil War in America,* Horace Greeley the second volume of *The American Conflict* (the first volume had come out two years earlier), Thomas Kettell his *History of the Great Rebellion,* and on and on. There seemed no end of interest in histories of the war and no shortage of writers to supply them.[20] Some sold as subscriptions, others as books in one or two volumes. The yearning for more prompted *Harper's Weekly,* following the leads of both *Leslie's Pictorial History* and the compendiums by popular historians of story, document, map, and illustration, to offer a serial version that seemed to wrap up all the many varieties in a single package. Published in segments over many years, it totaled nearly nine hundred pages and contained more than a thousand scenes, maps, plans, and portraits; a year-by-year, campaign-by-campaign, march-by-march (almost bullet-by-bullet) recounting; and thousands of detailed transcriptions of letters, dispatches, and even the lugubrious articles of impeachment brought against Andrew Johnson.[21] Whatever their format and however they were organized—by chronology, by campaign, by the fortuitous compilation of documents, by the dramatic fall and rise of the Union's fortunes—nearly all such volumes used images based on photographs and sketches. Several, including Benson Lossing's wildly popular *Pictorial History of the Civil War in the United States of America*, published in three volumes between 1866 and 1868, reproduced sketches made by the author himself.[22]

Consider *Battle of Antietam — Taking of the Bridge on Antietam Creek* (figure

11), published in Headley's *The Great Rebellion,* as an example of the kinds of images that appeared in these books and how they functioned. It insists on a closer view than Forbes's on-the-spot sketch, *Frank Leslie's* engraving, or Gardner's photograph. While in the latter three works the bridge itself forms an integral, architectural center around which the action unfolds, in Headley's version it is reduced to a supporting role, literally, as Union troops race across its span. The flag flies, the smoke billows, the officer on his steed charges, the bayonets thrust forward—the whole of it rushes from right to left and from here to there. The energy and momentum are consonant with the text. "'Forward!' ran along the line, and it sprang forward with a ringing cheer," Headley wrote of the first assault. The soldiers "reeled and staggered back"; they "pressed fiercely on" again; they "poured like a torrent" through the enemy, "hurling it back broken and confused"; the enemy came back "like successive waves of the sea"; and the Union troops counterattacked "with a rapidity and resistlessness of a whirlwind." The battle on the bridge was like some great tidal movement back and forth. Why? "If the bridge is lost, all is lost," General McClellan exclaims in Headley's text.[23] The picture did not merely illustrate the story but embodied its urgency and surging flow in its very structure.

On a spectrum of a friendliness to narrative, Headley's picture was most amenable, Forbes's drawing less so, and *Frank Leslie's* print somewhere in between. But Gardner's photograph—that was another extreme matter. It was so utterly resistant to storytelling of this sort, so empty of even the smallest markers of the confrontation, so reliant on a prodigious act of imagination to fill the scene that it could not easily be matched with the kinds of texts being published. Set alongside florid prose, it seemed incongruous. It was, simply put, antinarrative.

Perhaps Gardner's sensitivity to the differences between his book and those being published by others helps explain the disclaimer in the *Photographic Sketch Book*'s preface. "Verbal representations of such places, or scenes, may or may not have the merit of accuracy," Gardner wrote, "but photographic

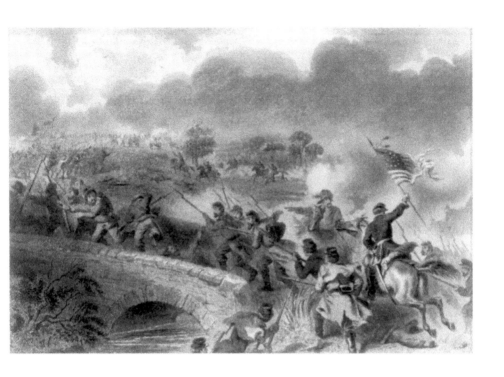

Figure 11 Unknown artist, *Battle of Antietam—Taking of the Bridge on Antietam Creek*, ca. 1865.
Courtesy of the Library of Congress.

presentments of them will be accepted by posterity with an undoubting faith." And as if recognizing that his photographs showed no more but also no less than "places," he stressed not the action or movement of the war but the many "[l]ocalities that would scarcely have been known." The letterpresses accompanying the pictures usually emphasize the same: *this* landing, *this* encampment, *this* house, *this* commissary, *this* view. The words often point at the concreteness of the pictures, since what the photographs show are not events but things.

HOW, THEN, SHOULD WE characterize the *Photographic Sketch Book*'s vision of the Civil War, so seemingly self-conscious of its means? To the histories already being published about the war, which gathered details, tracked movements, narrated battles, outlined strategies, promoted personalities, made some men heroes and others villains, transcribed documents, tallied the dead and wounded, insisted on the telling detail, and provided epic drama, the *Sketch Book* added a different account. It asked the simple question "What is war?" and proposed a less-encompassing, less fact-laden, and ultimately, for Gardner's contemporaries, less usable kind of answer. It is made up of assorted camp scenes, the pretty vistas on the march, the chance encounter with men, the isolated house, the lonely boat, and yes, also the unexpected dead body, the ruin, the silent mortar and empty battlements, and the meanings one could try to wring from them. Or to put it another way, it is composed of anecdote, interruption, serendipity, and pure contingency, the kinds of things the camera was best equipped to capture and underscore. There was no overarching narrative, only a "sketchbook" account, full of digressive and disconnected musings that spoke to the personal experience and to the view of the photographer on the ground and his very human effort to engage events, usually belatedly. In contrast to the histories, the *Photographic Sketch Book* constructed a smaller, more limited understanding against the larger, fiercer backdrop that is mostly implied but never directly addressed.

Indeed, most of the scenes in the *Photographic Sketch Book* make no clear reference to the campaigns and no tally of the army's movements but instead

offer vignettes associated with camp life—the tents of the Sanitary Commission here (no. 51), another for the Christian Commission there (no. 53), yet another for the Commissary Department (no. 61), a church built by volunteer engineers (no. 74), and even a gathering in front of the *New York Herald*'s field office (no. 56). The second-largest number of photographs is devoted to panoramas—several desultory views along the North Anna River, for example, and several more along the James, Potomac, Appomattox, and Rappahannock. Of course, a readership attentive to the many news reports, popular histories, and illustrated magazines published during the span of the war held a general sense of the Army of the Potomac's movements and fortunes, the sequence of events that led to this battle or that siege, the promotion or demotion of this commander or that, the key campaigns and important turning points. Perhaps they needed only the scantiest of promptings to organize and understand the *Photographic Sketch Book*'s movement against a more familiar story line. Gardner made sure to include as many references to sites as possible—his titles almost always incorporate them—as if calling on an imaginative geography he assumes is already vividly etched in his reader's mind. But the signposts were scant indeed and, unlike the creators of all those other popular works being published, he did not connect them. How a photograph of the quartermaster's tent related to another of a pontoon bridge, or of a mortar battery, or of John Henry is left unexplained. The questions of how and why we find ourselves along the banks of the North Anna and then suddenly along the James are never addressed. The overall effect is less of a geographic or narrative drive than of a collection of haphazard scenes.

The war, the *Photographic Sketch Book* declared, could not be narrated any more cohesively than that. It was too large to comprehend in any way except by attending to the very material things with which one came into contact in the field, at camp, or on the march and to the very limited glimpses one was afforded. Despite what the illustrators and popular historians were offering, the meanings of war had to be derived from those more quotidian experiences, which themselves had to be essayed with a healthy respect for their opaque-

ness. The camera was especially good at insisting on that respect because it cap-
tured the obdurate hardness and physical texture of things. The urge to make
stories or spin out metaphors always ran up against brute materiality. Words
were hardly incidental in the *Photographic Sketch Book*—the letterpresses were
everywhere—but they had to compete with, not merely take for granted, the
presence of images. They offered anecdote, sometimes apropos but occasion-
ally contradictory, often unreliable. Moreover, war could not be viewed ex-
cept retrospectively, as a memory so surpassingly vivid but also so distant and
distancing. One had to maintain a sense of one's lateness in coming to it.

THE PARTITIONING OF THE WAR into isolated and belated parts helps us un-
derstand several seemingly odd choices by Gardner on what and, significantly,
what not to include in the *Photographic Sketch Book*. Take, for example, the
vignettes related to the Battle of Antietam. In 1862, in the aftermath of the
battle, Gardner and Gibson had taken pictures that were among the most fa-
mous of the war (figure 12). When Brady displayed them in his New York
gallery later that year, they sent a shiver through at least one viewer's spine.
"We recognize the battle-field as a reality," a reporter for the *New York Times*
observed in a well-known passage,

but it stands as a remote one. It is like a funeral next door. . . . It attracts your attention,
but does not enlist your sympathy. But it is very different when the hearse stops at your
own door, and the corpse is carried out over your own threshold. . . . Mr. Brady has done
something to bring home to us the terrible reality and earnestness of war. If he has not
brought bodies and laid them in our door-yards and along streets, he has done something
very like it. . . . These pictures have a terrible distinctness.[24]

That October, *Harper's Weekly* published engravings based on the photo-
graphs and distributed them widely.[25] A year later, Oliver Wendell Holmes was
still grinding his teeth as he recalled the photographs: "[A]ll the emotions ex-
cited by the actual sight of the stained and sordid scene, strewed with rags, and
wrecks, came back to us, and we buried them in the recesses of our cabinet as

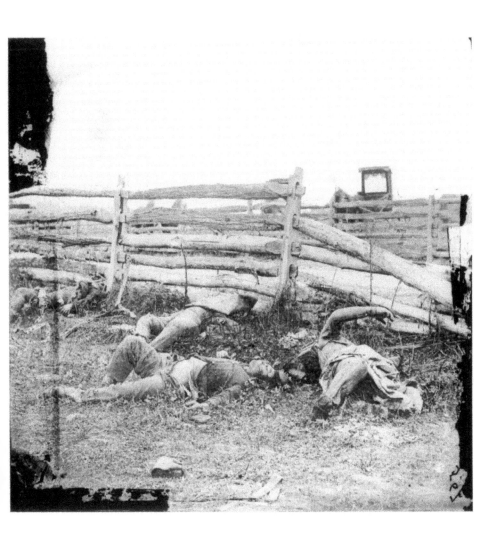

Figure 12 Alexander Gardner, *Killed at the Battle of Antietam*, 1862. Courtesy of the Library of Congress.

we would have buried the mutilated remains of the dead they too vividly represented."[26] The discussions swirling around the discomforting pictures helped enlarge Brady's already sizable reputation; and while no mention was ever made by Brady or by journalists of Gardner or Gibson and no popular attention immediately came their way, Gardner saw from the morbid interest which of his images most disturbed and piqued his audience. When he left Brady's employ in late 1862 (he had felt the snub of being unrecognized and unappreciated by Brady), he took all the Antietam negatives with him and soon made them the basis of his own series of popular stereoviews and album cards. Throughout the war, he no doubt earned a handsome income from them.

Given the enormous popularity and familiarity of the grisly Antietam pictures, it may strike us as bizarre that the *Photographic Sketch Book* contains none of them. It instead opts for a curious set of photographs: of Antietam Bridge (no. 19), Burnside Bridge (no. 20), Dunker Church (no. 21), and a signal tower on Elk Mountain that overlooked the battlefield (no. 22; figure 13). As a group, they insist on their silent stillness—the men at the signal tower are poised in a tableau against the wooden platform. Gardner even chose a more recent picture of Dunker Church, made years later after the building had been repaired, instead of a picture of it immediately after the battle, full of bullet holes and broken shingles. Why these scenes of emptiness and distance and not his famous and terrifying pictures of the dead? "Very little now remains to mark the adjacent fields as a battle ground," he wrote in the letterpress accompanying his picture of Antietam Bridge. The pictures could not summon any of those remains.

Later in the *Photographic Sketch Book,* Gardner would use his photographs of the dead at Gettysburg to provide the kind of shock that his pictures of the dead at Antietam had delivered in Brady's studio. Today, they are among the war's most famous images (no. 36; figure 14). But in the context of the *Photographic Sketch Book,* they are unique and belated—offered after the scenes of Antietam and of its blood and gore that readers, attentive to the war and its well-known imagery, had been prepared to find. Gardner's choice seems to

Figure 13 Timothy O'Sullivan, *Signal Tower, Elk Mountain, Overlooking Battle-Field of Antietam* (no. 22 in the *Photographic Sketch Book* [University of Pennsylvania version]), 1862. Courtesy of the Library of Congress.

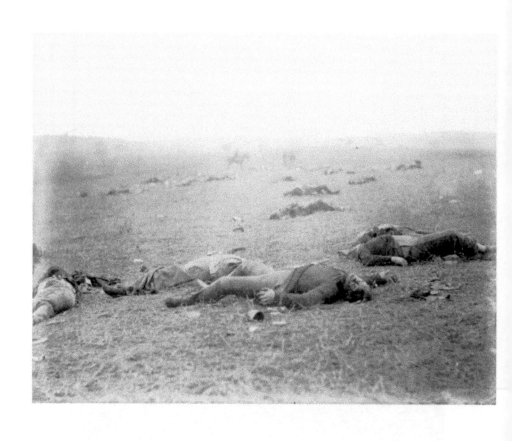

Figure 14 Timothy O'Sullivan, *A Harvest of Death, Gettysburg* (no. 36 in the *Photographic Sketch Book*), 1863. Courtesy of the Library of Congress.

be a deliberate act of deferral and an insistence on a different, more self-conscious kind of imagery than what readers had expected. Perhaps it was for the same reasons that Gardner enlisted two different versions of the signal tower on Elk Mountain (figure 15), as if he could not decide which might better capture such an important scene. Of the few surviving copies of the original printings of the *Photographic Sketch Book,* some contain one version, some the other.[27] The only other place in the whole collection where different pictures appear is the opening photograph for volume 2. "To the hero of Antietam belongs the credit of first developing and fully appreciating the value of a corps of signalists," he wrote, because those men detected "by their skill, vigilance, and powerful glasses, every movement of the enemy, reporting them instantly by a few waves of their flags to the Union Commander." They took proper vantages over the fray, they saw from a distance, they witnessed, they signaled, they observed. Of course, when Timothy O'Sullivan made these photographs, the battle was long over; he had asked the men to strike poses simulating their battlefield behavior. One man even holds an eyeglass as if he were spotting the enemy, although during the actual shoot, he probably looking at empty space or—even more fittingly—at a place where the enemy had been long before. In all this, he was most like a photographer.

HAVING PLUMBED THE PHOTOGRAPHIC NATURE of the book—its relation to the profession of photography, to the wider urge to visualize the war, to the comprehensive histories being published, especially those with images; its general differences from these histories, especially in its commitment to the limited view and the celebration of vignette over narrative—we ought to ask what is lost and gained by this perspective. How does this photographic understanding help us sort out the historical meanings of the *Sketch Book,* particularly in relation to the all-important subjects of slavery and emancipation? What is the payoff of the book's adamantly photographic vision? For an answer, I'll consider one of the *Sketch Book*'s most famous images of African Americans, *A Burial Party, Cold Harbor, Va.* (see figure 2). And I'll argue that

Figure 15 Timothy O'Sullivan, *Signal Tower, Elk Mountain, Overlooking Battle-Field of Antietam*
(no. 22 in the *Photographic Sketch Book* [Library of Congress version]), 1862.
Courtesy of the Library of Congress.

its image of blacks is attributable not to any large political allegiance to, or sympathy with, the plight of ex-slaves on Gardner's part, as one might expect, but instead to a more specific commitment to the new nature of his book. Furthermore, it made a connection between an antinarrative medium and an antiheroic understanding of the war's survivors.

Taken in April 1865, the last month of the war, *A Burial Party* pictures five black men, newly emancipated, gathering and burying the remains of soldiers killed in two earlier battles, Gaines' Mill in 1862 and Cold Harbor in 1864. Those battles had been fierce, two of the most violent clashes in and around Richmond. In the 1864 battle in particular, the bloodshed had been enormous. Lee's Army of Northern Virginia had hunkered down in earthworks and trenches and prepared for a war of attrition. Grant's Federals had responded by launching assault after assault on the makeshift line at Cold Harbor, Grant purportedly vowing to storm and fight on the line "if it took all summer."[28] The strategy was bad and the results were worse: the Federals repeatedly charged the earthworks like cows headed to slaughter, suffering seven thousand casualties in a single morning in early June. The dead lay everywhere, but there was no time to bury them; the two armies continued to meet and clash in skirmishes for the next two weeks and then fought a prolonged pitched battle at nearby Petersburg that helped the Union open the door to Richmond, the Confederate capital, and soon after win the war.

According to the conventions of the day, if the armies could not accomplish the task of burying the dead, the responsibility fell to the townspeople who lived nearby. In this case, the locals in and around Cold Harbor did not comply. "It speaks ill of the residents of that part of Virginia," Gardner wrote in the letterpress accompanying the picture, "that they allowed even the remains of those they considered enemies, to decay unnoticed where they fell." Historians name the hesitation on the part of soldiers to charge an entrenched line the *Cold Harbor syndrome,* but the term could just as easily refer to the paralyzing horror at the sight of so many decomposing bodies. In the time that passed between the battles and the photograph, maggots and wild animals

turned the soldiers into skeletons. In the photograph, the skulls and ragged clothes have been heaped into a tangle, the remains of each man no longer clearly distinguishable or kept apart but simply jumbled together indiscriminately. It was neither insensitivity nor desecration of the soldiers' bodies that brought about the heap. The party was doing its best to give the dead proper resting places, digging individual graves for, presumably, individual men, as the picture declares. But the task of collecting and identifying the bones of any single soldier must have been unceremonious and, at best, arbitrary. After nearly a year of exposure to the elements and the foraging of wild animals, the bones surely were hopelessly scattered about. Those of one man must have gotten buried with those of another, the hodgepodge in each grave making each of them doubly unmarked. Falling off the cart, an old boot serves as a reminder of the uniforms and official identities of the men—it was a good shoe with a thick sole and heel and probably belonged to a Federal (the poor Confederates notoriously wore thinning boots, and some simply went barefoot)—but it also serves as a contrast to the unidentified and unidentifiable dead everywhere else. Gardner was particularly sensitive to the near impossibility of naming any of the men, noting that "a singular discovery was made, which might have led to the identification of the remains of a soldier. An orderly turning over a skull upon the ground, heard something within it rattle, and searching for the supposed bullet, found a glass eye." But such a find was rare, as Gardner suggested, and in this case morbid.[29]

From the perspective of 1865, when Gardner began selecting and assembling his anthology of words and images, the war for many observers had something to do with burying the dead and also, somehow, after years of ignominy and relentless bloodshed, honoring them. It also had to do with the living, their relation to devastation and ruin, and their wish that countless deaths might in some way be linked to a more useful social purpose. And for some it had to do with celebrating the heroism of those who nobly prosecuted the war, like those who had fought at Cold Harbor, and laying blame on those who dishonored it, like those hard-hearted locals who had apparently felt no

responsibility to the community at large and seemingly acted improperly, even unethically.

One way to understand *A Burial Party,* then, might be in its introduction of slavery and emancipation, in the form of the black men who are the sole agents of the scene, into an overall stocktaking of the war. In this, Gardner was extraordinarily unusual. White observers after the war, even the most loyal Republicans, often preferred not to tackle the question of the African American presence, especially as the century wore on and the promises of racial equality faded away.[30] But thematically, the idea of blacks as central actors in the postwar era is put forth in contradictory ways in the *Photographic Sketch Book.* Including *A Burial Party,* black men and women visibly appear in only six of its one hundred images, and only in their most caricatured antebellum roles— as meek servants, childish entertainers, or brute laborers for their white folk. A partisan of the Northern cause, Gardner certainly could have drawn pictures from his vast collection, some three thousand pictures in all, to offer another vision of them. He had done so already. Compare his *What Do I Want, John Henry?* (see figure 1) to a photograph called *Intelligent Contrabands* (figure 16) that he published three years earlier in his popular 1863 series, *Photographic Incidents of the War.* In *John Henry,* with its image of lounging officers and doting servant, the old, unreconstructed relations between whites and blacks are summoned again, as the young John Henry provides food and drink for his relaxing superior. As the title suggests, the officer, a "Captain H," hardly needs to name his desires; a simple question elicits his obliging servant's instinctive and knowing reply. A hat to protect Captain H's head from the sun? a drink to quench his thirst? a boot that needed care and "other attentions"? What do I really want, John Henry? The young servant already knew the answers. By contrast, in *Intelligent Contrabands,* the two young black men, freed from the plantations and the shackles of humiliating servitude, have pitched a tent for themselves and lounge with as much freedom and leisure—a good cigar, ladles of food and water, a cool shade—as was normally reserved for their ex-masters. They could name their own desires and attend to them as they saw fit.

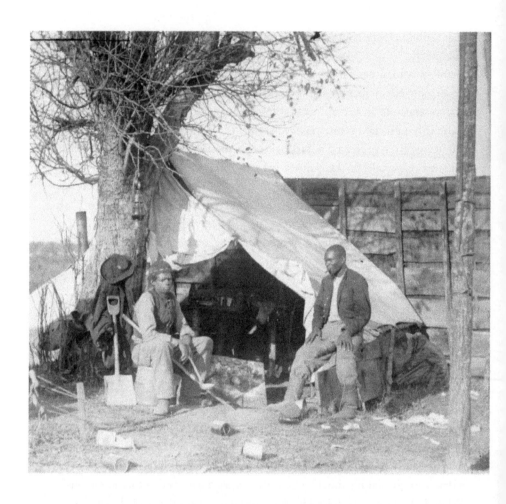

Figure 16 Timothy O'Sullivan, *Intelligent Contrabands* (from the series *Photographic Incidents of the War*), 1863. Courtesy of the Library of Congress.

In case the emphasis—on leisure and work, intelligent self-reliance and dot-
ing service and the differences in meaning these had for blacks and whites—
was not clear enough, and in case the manner of its enlistment in the *Photo-
graphic Sketch Book* was not apparent, Gardner stressed it in his letterpress
accompanying the picture:

Although [John Henry's] head resembled an egg, set up at an angle of forty-five degrees,
small end on top, yet his moral and intellectual acquirements were by no means common.
His appreciation of Bible history was shown on many occasions. For instance, he always
considered Moses the most remarkable of quartermasters, in that he crossed the Red Sea
without pontoons, and conducted the children of Israel forty years through the desert with-
out a wagon train.

With wisdom such as this he would enlighten his sable compeers. Meanwhile, the Cap-
tain became a Colonel. Richmond was evacuated, and John Henry became a resident of
the rebel capital. Here freedom burst upon him in a new light; he formed new associations–
principally with the other sex–to raise whose spirits he would appropriate his employer's.
As his mind expanded, boots became monotonous, manual labor distasteful, and a disso-
lution of partnership inevitable.

John Henry's "intelligence" is all hemmed in by his limited experiences in
the camps and is best described with a gesture toward caricature—the dull-
witted Negro of minstrelsy—that has to be seemingly applied at every turn.
His newly found freedom brings about a newly found pursuit of leisure,
though whether this "new light" should be lauded by readers of the *Photo-
graphic Sketch Book* is clearly another matter. The tone, style, and imagery of
this letterpress were much reproduced during both the Civil War and Re-
construction by the opponents but also by the proponents of emancipation. In
the matter of imagining a new place in society for freedmen, Gardner, an old
socialist who had once helped found a utopian colony, could not be expan-
sive. Even in *A Burial Party,* Gardner didn't care to think carefully about the
black men; he was far more concerned with the lost identities of the Union
soldiers being gathered than with the men who were in front of the lens and

doing the moral work of burial that the hard-hearted locals of Cold Harbor had refused.

Yet *A Burial Party* represents the single image in which African Americans appear in anything remotely like a positive light. And the reason seems clear. Its insistence on picturing the remnants of a battle long over and its emphasis on the efforts to gather the scattered remains of the men who fought in it were in keeping with the *Photographic Sketch Book*'s overall cast. In this case, the black men were most like the photographer: they came afterward, when the momentous and monstrous events of war were already being ushered into history. It was that similarity that brought empathy, or perhaps just a vague understanding of the freedmen's position and plight. They were not heroes (neither blacks nor whites would have so viewed them) but were merely survivors. All they could do was try to reconstruct the scene from the "things" still in evidence and then, using the heavy tools they possessed, lay those things to rest.

In the connection between photographer and black man, an antinarrative medium met an antiheroic sitter. They found common ground, and in a sense the *Photographic Sketch Book* found its final, proper subject. For the entire book, predicated as it is on visual anecdote and serendipity, has no protagonist. During Reconstruction, when the promises of freedom and equality, the ostensible reasons for the war, seeped slowly away, the book could never be expected to gain one. Gardner's collection addressed an unromantic past in the face of an uncertain, even unpromising future, and in *A Burial Party* he found in the figures of the black men a means of engaging both. It presented not a cause for celebration but, with strange aptness, an awareness through photography that antinarrative and antiheroism, forms of fracture and the impossibility of exaltation, were what lay in store in the modern world.

GIVEN THE WAY IN WHICH MOST of Gardner's contemporaries experienced and understood images of war in the magazines and history books, we should not be surprised that the *Photographic Sketch Book* was not a huge success. Although Gardner seems to have produced a very limited number of what, with

its enormous price tag, was meant as a luxury album, it never gained the swell of approval that might have resulted in later or more popular editions. It garnered no criticism or reviews, and after brief mentions in the papers and magazines offering it for sale, it quietly disappeared. Perhaps this disappointment explains why Gardner took a different career path afterward. Although he continued as a photographer, heading west soon after the war to picture the railroads and frontier towns, he increasingly turned his attention to mutual aid and relief associations. For example, he edited the *Endowment Journal* and served as secretary of the Masonic Mutual Relief Association for nearly a decade; toward the end of his life, he was elected its president. When a eulogist looked back on Gardner's long life, he noted Gardner's time as a photographer with the Army of the Potomac but drew from it a curious moral: "During these years he was a close student of social conditions in all things, and was busy in suggesting comprehensive plans to aid those whose lot was cast in the vale of poverty, and by actual experiment prove the soundness of the principle of cooperation, the wisdom of a mutual reliance upon each other in order to secure the best and largest results with the least possible expense."[31] The account is odd and not much borne out by the photographs themselves. But it suggests that Gardner had by then become more famous for his work in social relief and had finally found a way to directly address trauma and devastation in ways that his contemporaries could more easily understand.

With the single exception of George Barnard's *Photographic Views of Sherman's Campaign,* there was nothing really like the *Photographic Sketch Book* in its day, at least if we consider only photo compendiums of the Civil War.[32] But countless publications made a place for images about the war. The defining quality of the *Photographic Sketch Book* is that in turning to photographs as opposed to words as the motor of his book, Gardner understood and allowed the camera's peculiar qualities to structure it. With them, the image of war took on a different quality, closer to the unsettlingly palpable, irretrievable, and yet portentous thing that it was.

Verbal Battlefields

Elizabeth Young

ALEXANDER GARDNER'S *Photographic Sketch Book* (1866) is justly celebrated for its photographs, but to a literary critic, a startling feature of the original volume is how many words are in it. Each of its one hundred images is accompanied by a substantial piece of text, written by Gardner, which seems too long to be considered a caption; the shortest is more than 115 words, the longest more than 650.[1] In this wealth of words, Gardner's book differs sharply from the other volume of Civil War photographs that appeared at this moment, George N. Barnard's *Photographic Views of Sherman's Campaign* (1866). Barnard's photographs were described in a pamphlet bound separately; apart from the title and contents pages and a short caption beneath each image, there were no words in the book itself.[2] By contrast, an advertisement for Gardner's *Photographic Sketch Book* touted its words as "sufficiently explicit and graphic to assist the memory of American citizens, who may spend a few hours tracing the war through these volumes, without the necessity of referring to any history whatever."[3] Gardner's words were intended to be more than supplements: they were to make the volume a world unto itself.

Indeed, these words are central to how the reader understands the images of the *Photographic Sketch Book*. Gardner restaged the composition of his Gettysburg photographs—the most famous in the volume—to create more dramatic and partisan effects. For example, he dragged the corpse in *Home of a*

Rebel Sharpshooter (no. 41 in Gardner's volume) forty yards from where it orig-
inally lay and propped a rifle next to it. These manipulations are now well
known,[4] but what goes unremarked is how much the words in the volume af-
fect the issue of restaging and its corollary, the charge of inauthenticity. Gard-
ner's words create the presumption that the setting of *Home of a Rebel Sharp-
shooter* is authentic: "The artist, in passing over the scene of the previous days'
engagements, found in a lonely place the covert of a rebel sharpshooter, and
photographed the scene presented here." If this description had instead con-
cluded, "The artist moved the body of the rebel sharpshooter to the lonely place
seen here," the photograph would still be staged, but it would no longer claim
to represent what it does not. To the extent that these most famous of Civil
War photographs are now known for being inauthentic, it is not their images
that make them so: it is their words.

At the same time that Gardner's written texts shape the photographs, they
also function as self-contained works. This autonomy is both literal and lit-
erary. In the original volume, each written text was printed not on the page
facing the photograph—as is customary in modern reprint editions—but on
the page preceding the photograph, in the same right-hand position; the left-
hand page was blank.[5] With both image and text appearing on the recto, each
written text had to be viewed independently, opposite white space, before
the reader could turn the page to get to the photograph. Each block of writ-
ten text was also centered on the page, enhancing its status as an object to be
viewed, rather than set as a caption, which customarily runs below an image
(figure 17). Literally bound to be read separately, literally without an image in
sight, the words in the volume not only merit but demand examination on their
own.

The spatial independence of Gardner's words is complemented by their lit-
erary autonomy. While the written texts often start by naming themselves as
descriptions of an image to come, some begin without the suturing language
of "Here is" or "This is," and others do not refer to the image at any point.
Many suggest an attempt by Gardner to create literary narratives full of

Figure 17 Alexander Gardner, *A Burial Party on the Battle-Field of Cold Harbor* (letterpress; no. 94 in the *Photographic Sketch Book*), 1865–66. Courtesy of the Library of Congress.

metaphor, tone, plot, subplot, character, dialogue, and voice. For example, *Field Where General Reynolds Fell, Battle-Field of Gettysburg* (no. 37) offers figurative imagery that competes with the photograph to come: "The faces of all were pale, as though cut in marble." The text accompanying *A Harvest of Death* (no. 36; see figure 14) begins with an elaborately literary sentence: "Slowly, over the misty fields of Gettysburg—as all reluctant to expose their ghastly horrors to the light—came the sunless morn, after the retreat by Lee's broken army." This sentence establishes a plot for the image, offering a narrative movement forward in time ("slowly . . . came the sunless morn"), personified objects ("reluctant fields"), and a profusion of adjectives ("sunless morn," "broken army"). Such accounts are primary rather than supplementary texts, declaring their literary independence from the images that follow.

Yet despite the centrality of Gardner's words to the *Photographic Sketch Book,* they have received surprisingly little critical scrutiny. Historians of photography acknowledge the volume as the foundation of the photo-essay tradition, but they tend to dismiss the texts themselves as "purple prose," or to move quickly through them en route to the photographs; accounts of Civil War literature seldom include them.[6] This essay focuses on Gardner's words, analyzing the interplay between verbal and visual registers within the *Photographic Sketch Book* and setting his words—which I will term *literary sketches*—in the context of Civil War literary culture. I interpret his sketches in relation to each other, to the photographs, and to other literary works; Gardner appears here in conversation with Louisa May Alcott, Frederick Douglass, Oliver Wendell Holmes, Washington Irving, Harriet Jacobs, Herman Melville, Harriet Beecher Stowe, Walt Whitman, and other writers.

I argue for the importance of interpreting the *Photographic Sketch Book* as a work of writing as well as image making, one whose literary dimensions embody, exceed, amend, contradict, and otherwise complicate the book's photographs. In particular, the words of the *Photographic Sketch Book* offer alternative representations of racial hierarchy and rebellion; the racial conflict often effaced within the images is given different scope through Gardner's words.

I begin with the opening of the volume, including its preface, title page, and first literary sketch; analyze four sketches with a focus on their racial instabilities; and close with the tensions within the volume's endings. Throughout, I show that there are numerous civil wars in Gardner's *Photographic Sketch Book,* centered not only on the regional contest he presents in an overtly partisan way but also on more ambiguous internecine conflicts between black and white male bodies and between visual and verbal ways of representing them.

In making these preliminary investigations into the verbal battlefields of the *Photographic Sketch Book,* I do not claim that the words are superior to the photographs aesthetically. Nor am I arguing that they are more radical politically. Rather, my emphasis is on their importance to our understanding of both the photographs and Civil War literary culture. Gardner's *Photographic Sketch Book* was a defining moment in the history of the photographic medium, but that moment was defined by words as well as images, and his words are indispensable to how his volume reconstructs the image of war as well as the warring nation.

IN THE RICH AND UNDERSTUDIED visual culture of the Civil War, there were many varieties of what W. J. T. Mitchell has called "imagetexts," or "composite synthetic works . . . that combine image and text."[7] Newspapers such as *Frank Leslie's Illustrated Newspaper* and *Harper's Weekly* contained lavish illustrations, captioned and juxtaposed with articles. Illustrated book-length histories of the Civil War began to appear as early as 1861; even war histories that did not feature illustrations, such as Frank Moore's multivolume anthology *The Rebellion Record,* included portraits and maps. The political cartoon, popular during the war, relied on words in both the dialogue within the image and the caption at its base. Verbal and visual elements also intermingled in more unusual forms of print media, such as patriotic envelopes. The bulk of this material was pro-Union, but Confederates combined words and images in many texts marking their new nation, from songs to stamps. From new Northern newspapers devoted to illustrating the Union cause to the

emerging iconography of the Confederate States of America, imagetexts abounded in the Civil War. Its visual culture was wordy; its verbal culture, visual.[8]

Photography was central to these hybrid wartime forms. Illustrated newspapers converted photographs into engravings and surrounded them with words; stereoscope cards covered the reverse side with words; photographic portraits included the name of the studio and the subject, and sometimes more complex texts—as in the captions below Sojourner Truth's image on her cartes de visite, which she marketed to fund her political work: "I sell the shadow to support the substance."[9] Photography shaped the content and form of war literature. For example, Herman Melville's poem "On the Photograph of a Corps Commander" adapted the tradition of ekphrasis—the verbal representation of visual art—to photography,[10] while Oliver Wendell Holmes's influential essay "Doings of the Sunbeam" used war images by Mathew Brady, "so nearly like visiting the battle-field," to analyze the new medium of photography.[11] Gardner's book of Civil War words and images emerged not just from a verbal visual culture but from a war that prompted new writing on photography, both literally and thematically.

What, then, should we call the words in the *Photographic Sketch Book?* The volume is contemporary with Truth's photographic captions, Melville's ekphrastic poetry, and Holmes's wartime essays, and it overlaps with all of these while remaining distinct from each. The terms that Gardner's publishers used in advertisements were *letter-press* and *letter-press descriptions,* but these conflate the words with the process of producing them.[12] The most productive way to locate Gardner's words, I suggest, is as a new version of an established literary genre, the sketch, which already incorporated visual modes in complex ways.

The sketch was originally a visual form, and it remained popular as such during the Civil War. But it was also a common literary genre in nineteenth-century America, inaugurated by Washington Irving's *Sketch Book of Geoffrey Crayon, Gent.* (1820–21). In "The Author's Account of Himself," Irving introduces the idea of a literary "sketch book":

I have wandered through different countries and witnessed many of the shifting scenes of life. . . . As it is the fashion for modern tourists to travel pencil in hand, and bring home their portfolios filled with sketches, I am disposed to get up a few for the entertainment of my friends. . . . [However,] I fear I shall give equal disappointment with an unlucky landscape painter, who had travelled on the continent, but . . . had sketched in nooks and corners and bye places. His sketch book was accordingly crowded with cottages, and landscapes, and obscure ruins; but he had neglected to paint St. Peter's. . . .[13]

In the voice of Crayon—his name a pun on sketching—Irving signals that a sketchbook will be devoted to wandering, partiality, and obscure spaces, strategies that may generate disappointment in the reader. Sketching provides both a visual analogy for the form and a preemptive alibi for its ostensible insufficiencies.

After Irving, the genre quickly proliferated in American literature. As Kristie Hamilton has shown, the sketch acquired three distinct connotations, as signaled in its accompanying titles:

[First, there was] the analogy Irving had drawn between the prose form and the visual form that had inspired it: these writings were, thus, "pencillings," "crayon sketches," "night-sketches," "outlines," "lights and shadows," and "inklings." Or, sketches might be identified by their subject matter, which . . . could be communicated "desultorily" (via Irving), allowing for digression, and without the requirement of an elaborate plot; sketches captured "scenes," "characters," "incidents," "sights," "recollections," and "reveries" on the page. Or, finally, authors evoked the sketches through its association with the brevity and ephemerality that made this form at once so accessible to so many and so consonant with an age that was perceived to be marked by a new momentum, a new pace, in which one must see quickly and write with haste, offering "dashes," "jottings," "peeps," "glances," and "glimpses."[14]

Along with these three traits—visual partiality, digressive plot, and compositional haste—the literary sketch was distinctive in its wide range of practitioners; sketches were written by many women writers and writers of color.[15]

Thus Harriet Wilson's novel *Our Nig* (1859) was subtitled "Sketches from the Life of a Free Black," while Harriet Jacobs's *Incidents in the Life of a Slave Girl* (1861), published under the pseudonym Linda Brent, was suffused with mentions of the sketch form, from its preface ("When I first arrived in Philadelphia, Bishop Paine advised me to publish a sketch of my life") to the title of chapter 9, "Sketches of Neighboring Slaveholders."[16] "Geoffrey Crayon, Gent." had become "Linda Brent," African American woman, as the action of the sketch migrated from traveling through the Continent to escaping from slavery.

The sketchbook was well suited to representing the Civil War. Its distinguishing traits coincided with the experience of wartime: traversals of the countryside, haphazard and rapid events, and a range of novel experiences glimpsed in new settings. In *Hospital Sketches* (1863), for example, Louisa May Alcott assembled a collection of stories based on her experience as a Union army nurse in a Washington, D.C., hospital, written in the semicomic voice of a nurse named "Tribulation Periwinkle." Adapting the brevity and partiality of the sketch to war work, Alcott also commented on its visual form. In the voice of Periwinkle, she says of her patients, "I would have given much to have possessed the art of sketching, for many of the faces became wonderfully interesting when unconscious."[17] Turning sick soldiers into an exemplary artistic subject, Alcott uses "sketching" as a metaphor within her war writing as well as a defining genre for its form.

We can see Gardner's volume, then, as a further transformation of the literary sketch in wartime. The "photographic sketch book" combined sketching, a very old visual medium; the sketchbook, an established nineteenth-century literary genre; and photography, a new visual medium without any history in book form. Though Gardner's volume lacks the sustained first-person persona characteristic of the sketchbook—like Irving's Crayon or Alcott's Periwinkle—it shares with the form the structure of a series of brief, episodic texts, organized by travel and presented as partial. Viewed as sketches, Gardner's words are not a disposable supplement to the photographs but an intrinsic element of the genre to which the book belongs.[18]

The opening pages of the *Photographic Sketch Book* dramatize the complexity of its form. The title page implicitly emphasizes the "sketch" in "photographic sketch book." Credited to A. R. Ward, the illustration features the book's title in a wide oval, with a large Union flag draped to the side and Union army tableaux encircling it (figure 18).[19] At the left are battle scenes: a flag ripples in the wind, extending the flag at the image's center and putting it in the hands of soldiers riding into battle; above them, more soldiers march into the distance, another flag visible at the top of their ranks. To the right are camp-life scenes: Northern soldiers lounging in front of a tent, industriously digging under the command of an officer, conversing in camp on horseback, and training in crisp formation. Throughout these scenes, the soldiers look confident, the motif is pastoral, and the mood is cheerful.[20] The moment seems timeless, and all the bodies in it alive and intact. The image suggests the pictorial sketch tradition in a willfully partial mode. Here is the Civil War at its most—in the minimalist sense of the term—sketchy.

Having established this sketch mode, Gardner immediately alters it. The three-paragraph preface begins: "In presenting the PHOTOGRAPHIC SKETCH BOOK OF THE WAR to the attention of the public, it is designed that it shall speak for itself. The omission, therefore, of any remarks by way of preface might well be justified; and yet, perhaps, a few introductory words may not be amiss." Gardner first dismisses words, in the idea that the book "shall speak for itself," but then reverses position. The pose of diffidence—"perhaps," "may not be amiss"—suggests a stance of modesty, like that often assumed by sketch writers. The sentences are written in the passive voice, without an "I." This suppression of a subject is, perhaps, a way of sidestepping the collective nature of the photographs' authorship, scrupulously acknowledged in the multiple credits to each image. It is also a way of establishing that this is a literary sketchbook whose first-person voice, "speak[ing] for itself," will come from the combination of words and images that follows.

The second and third paragraphs specify the project's photographic dimensions. The second makes the pages of the book into objects of remembrance:

Figure 18 A.R. Ward, cover for *Gardner's Photographic Sketch Book of the War,* 1866.
Courtesy of the Library of Congress.

"As mementoes of the fearful struggle through which this country has just passed, it is confidently hoped that the following pages will possess an enduring interest. Localities that would scarcely have been known . . . have become celebrated, and will ever be held sacred as memorable fields." This awkward passage makes the "memento" into a relic, and the volume itself into a double reliquary: a sacred space about sacred spaces. The third paragraph outlines the role of photography in shaping this space: "Verbal representations of such places, or scenes, may or may not have the merit of accuracy; but photographic presentments of them will be accepted by posterity with an undoubting face." Gardner's contrast between inaccurate words and accurate photographs seems disingenuous, given the amount of restaging in the photographs. Even if we interpret the sentence as straightforward, its phrasing is curious: photographs "will be accepted by posterity with an undoubting face." The emphasis is on the future reception of photographs as true rather than on their inherent veracity, a focus on interpretation highlighted by the explanation, in the next sentence, of the volume's scope: "During the four years of the war, almost every point of importance has been photographed, and the collection from which these views have been selected amounts to nearly three thousand." Like Irving and Alcott, Gardner sets up the volume to come as his own partial and selective interpretation. In the preface, he does not so much move from the pictorial sketch to the photographic image as alter a literary form, the sketchbook, that already negotiated between images and words.

The first sketch, titled *The Marshall House, Alexandria, Virginia* (no. 1; figure 19) dramatizes this negotiation. The photograph depicts a large three-story building on a street corner; several people are visible in the foreground, but the emphasis here—as in many images in the volume—is on architecture. There are numerous words within and below this image: within, the title "Marshall House" and the names of adjacent commercial enterprises, including "Great Western Clothing Store," "City Bookstore," and "Dry Goods Store"; below, the designation "Plate 1," the caption, "Marshall House, Alexandria, Va., August 1862," and the credits, "Negative by Wm. R. Pywell" and

"Positive by A. Gardner." The name "Marshall House" appears both within and below. The words within constitute a kind of internal caption, suggesting the permeability between word and image and providing an internal point of connection from the photograph to the sketch on the preceding page. Anchored to "Marshall House," the literary sketch is less an external explanation for the photograph than an expansion of the words already within it.

This is the sketch in its entirety:

The Marshall House, at the commencement of the war, was a dingy old hotel, kept by a man generally known in that section by the name of Jim Jackson. It was in this building that Col. Ellsworth of the New York Fire Zouaves was killed, in May, 1861. Our troops had surprised and captured the city just before daylight, and as Col. Ellsworth was posting his troops about the town, he discovered a Confederate flag waving from the roof of the Marshall House. Accompanied by Private Brownell, the Colonel went up through the building after the flag, and on coming down was shot on the stair-case by the proprietor, Jackson. Brownell instantly killed Jackson, and with others hurried to Washington with Ellsworth's remains. The intelligence of his death was kept from the Zouaves for several hours, until measures could be taken to prevent them from destroying the city, which it was feared they would attempt in revenge for the killing of their commander. Brownell was shortly after appointed a lieutenant in the regular army. Relic hunters soon carried away from the hotel everything moveable, including the carpets, furniture, and window shutters, and cut away the whole of the staircase and door where Ellsworth was shot. Finally Northern men took possession of the building, and fitted it up for business, so changing the interior as to be scarcely recognizable by those who visited it in 1861.

The outlines of this story were familiar to audiences in the 1860s. Colonel Elmer Ellsworth was famous even before the Civil War began, for raising a regiment of Zouave soldiers; dead at 25, he became the subject of many songs, poems, and paintings. His story established a common currency for Union martyrdom and became a rallying cry for vengeance. A regiment known as Ellsworth's Avengers formed, and tribute poems exhorted,

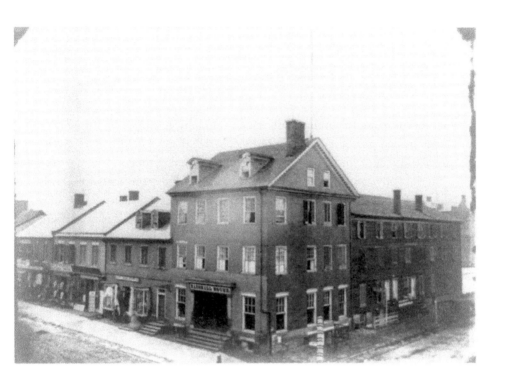

Figure 19 William Pywell, *Marshall House, Alexandria, Va.* (no. 1 in the *Photographic Sketch Book*), 1862. Courtesy of the Library of Congress.

Keep your dead Colonel e'er in view,
Wherever in this war you roam,
And let this shout your zeal renew:
"Remember Ellsworth! Zouaves, strike home!"[21]

Gardner was surely familiar with the iconography generated by Ellsworth's death: he had photographed him in 1860, before the war began, in a conventional full-length studio portrait of the young man in uniform.[22]

In the *Photographic Sketch Book,* however, Gardner represents Ellsworth very differently. Both visual and verbal commentaries usually focused on Ellsworth's body, particularly his beauty. For example, John Hay, writing anonymously in the *Atlantic Monthly,* rhapsodized that "[h]is person was strikingly prepossessing. His form, though slight . . . was very compact and commanding; the head statuesquely poised, and crowned with a luxuriance of curling black hair; a hazel eye . . . the eye of a gentleman as well as a soldier."[23] Even Ellsworth's corpse was praised: he was embalmed, in one of the earliest uses of the practice, and the results considered a great success.[24] But in Gardner's photograph of the Marshall House, there is no body of Ellsworth, live or dead. Nor is there an image of his Confederate murderer or his Union defender, figures common to the story, or even of the Confederate flag, which became a sacred extension of Ellsworth's body in popular accounts: "The rebel flag [was] stained with his blood, and purified by this contact from the baseness of its former meaning."[25] The Currier and Ives lithograph *Death of Col. Ellsworth,* for example, features Ellsworth's heroic body, outsized and tilted symbolically toward heaven, draped with the flag, and flanked by his assassin and avenger (figure 20).[26] Gardner's *Photographic Sketch Book* lacks any of these iconographic elements, making it impossible to "Keep your dead Colonel e'er in view."

But while Gardner's photograph evacuates bodies from the Ellsworth story, the literary sketch does the opposite, emphasizing them hyperbolically. The plot of the sketch turns on repeated instances of corporeal violation: the Union

DEATH OF COL. ELLSWORTH,

after hauling down the rebel flag, at the taking of Alexandria Va. May 24 1861

Figure 20 Nathaniel Currier and James Merritt Ives, *Death of Col. Ellsworth*, 1861. Courtesy of the Library of Congress.

capture of the city, Ellsworth's shooting by the proprietor, the potential vio-lence of the Zouaves, the looting of the "relic hunters," and finally the North-ern men taking "possession of the building." These actions constitute violence against bodies literal and symbolic; the "relic hunters," for example, penetrate the building's interiors. The house was a "dingy hotel" to start, further sug-gesting that it was already degraded, if not violated, from within. In Gard-ner's sketch, the Marshall House becomes, symbolically, both a fallen woman and a divided house, over whose body men battle to control the nation.

Violently embodying the photograph to come, this sketch also revises the imagery of the illustration it follows. In contrast to the pastoral scene on the title page, Gardner offers an urban, commercial setting; the rippling flags of the illustration are replaced by the decapitated flagpole of the Marshall House; the illustration's circular panorama of cheerful bodies has become a forward movement through waves of violation. The conclusion—"Finally Northern men took possession of the building, and fitted it up for business, so changing the interior as to be scarcely recognizable by those who visited in 1861"—suggests Union victory, but it does so in very secular and somewhat chilling language: restored nation as refreshed commodity.

Indeed, in contrast to the preface's language of making the battlefield "sacred" with a photograph, this sketch represents the act of memorializing the Civil War as a frenzy of looting. The image of "[cutting] away the whole of the staircase and door" takes apart the relation between the building's phys-ical stories and metaphorically hollows out the conventional iconography of the Ellsworth story. And as the Northern men "so [change] the interior as to be scarcely recognizable," so too does Gardner provide a new interior to the image of the Marshall House. Gardner himself is "fitting [the Marshall House] up for business," openly so: the price of the *Photographic Sketch Book* was a stag-gering $150. His sketch seems, in this context, to offer a self-reflexive com-ment on the dangers of commodification, as well as violation, inherent in the process of remembrance. The sketch provides a cautionary tale for the very act of commemorating the Civil War to which the volume is devoted.

At the same time, the sketch also gestures toward the most sacred and price-less story of male martyrdom in the Civil War, that of Abraham Lincoln. The Confederate flag on the Marshall House supposedly "swung insolently in full view of the President's House,"[27] another image of degraded femininity that brings Lincoln into the scene as an observer. Ellsworth was connected to Lincoln in other ways: he had worked in Lincoln's Springfield law office; his body lay in state at the White House; and Lincoln wrote a condolence letter to Ellsworth's parents.[28] While Gardner had photographed the president re-peatedly (see figure 4), in the *Photographic Sketch Book* he appears only once, in *President Lincoln on Battle-Field of Antietam* (no. 23; see figure 5). In this pho-tograph, he is very much alive, a head taller than the other men. But for an audience in 1866, the image of the live Lincoln's body was inevitably shadowed by that of his dead one. That shadow lingers, I suggest, in Gardner's choice to commence the volume with the story of Lincoln's symbolic son, Ellsworth. Lin-coln may be the absent photographic subject here—as well, perhaps, as the pho-tograph's absent viewer, watching the Marshall House from the White House. As the *Photographic Sketch Book* begins, Gardner both invokes and dismem-bers martyrdom: Ellsworth is the wounded torso of his Civil War body politic, while Lincoln is its posthumous eye, as well as its presidential head.

DISPERSED ACROSS BODY PARTS, Gardner's martyrs are, nonetheless, united in their whiteness. There is no mention of race in Gardner's opening sketch, even though the main activities of its plot—possession, violation, and commodi-fication—were defining acts of slavery. Where are black people in Gardner's Civil War body politic?

Gardner was a lifelong opponent of slavery; he was eulogized as "an abo-litionist from his earliest recollection, [who] remained an enemy of slavery until it was destroyed."[29] Yet only a half-dozen of the volume's hundred pho-tographs visibly include black people; only one includes an African American woman. None depicts the nearly 200,000 black men who fought for the Union army, in an era when African American and white writers consistently nar-

rated the achievements of black soldiers; contemporary with Gardner's volume, for example, was William Wells Brown's *The Negro in the American Rebellion: His Heroism and His Fidelity* (1867).[30] Numerous visual works depicted black soldiers in uniform, from recruiting posters urging black participation to photographs of armed black regiments to paintings of black veterans.[31] During the war black men were newly represented not only as "intelligent contrabands," as a Civil War photograph published by Gardner is titled (see figure 16), but also as armed and uniformed soldiers, fighting en masse for the Union and for emancipation (figure 21).

While Gardner's photographs do not participate in such efforts to expand the representation of African Americans, his volume is strongly shaped by racially marked characters and metaphors.[32] What Toni Morrison calls "a real or fabricated Africanist presence" in American literature is crucial to the *Sketch Book;* here, as in the canonical literary works she analyzes by white authors, "Americans choose to talk about themselves through and within a sometimes allegorical, sometimes metaphorical, but always choked representation of an Africanist presence."[33] In Gardner's volume, this representation is both verbal and visual, a duality that creates evocative asymmetries. The African American presence in the sketches of the *Photographic Sketch Book* is different from that in the images. The sketches offer alternative literary vocabularies that throw the dynamics of racial hierarchy—including its erotic connotations—into exaggerated relief, if not also providing narrative templates for their possible reversal.

The sketches and photographs in the *Photographic Sketch Book* are asymmetrical in relation to the color line. Sometimes the literary sketch omits any references to black figures in the photograph. For example, the image titled *Residence, Quartermaster Third Army Corps, Brandy Station* (no. 52) includes a black man, in profile, at the center, yet he is not mentioned in the literary sketch. *Breaking Camp, Brandy Station* (no. 63; figure 22) features a black man leaning against an open chimney and looking directly at the camera. Not only is this man not mentioned in the sketch for this photograph; he is aggressively

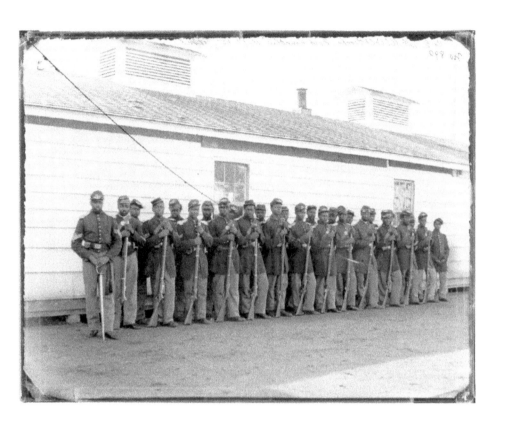

Figure 21 Unknown photographer, *District of Columbia. Company E, 4th U.S. Colored Infantry, at Fort Lincoln*, 1862-65. Courtesy of the Library of Congress.

erased in Gardner's assertion that "[t]he photograph possesses interest only as an illustration of the mode of life of the army in winter."

More commonly, though, race is marked in the text but not in the photograph. For example, *Quarles' Mill, North Anna, Va.* (no. 67) depicts a mill on a river and the surrounding landscape; the image is unpopulated. In the literary sketch, however, Gardner writes: "In the river the negroes caught delicious terrapin, and the soldiers varied their rations with messes of catfish." "Negroes" and "soldiers" are segregated terms here; "negroes" fish, and "soldiers" eat. A racially marked plot ensues, for the mill was used to house Confederate prisoners, including a woman who was "[a] degraded, wild specimen of humanity, of Irish extraction[;] . . . she proved the centre of interest to the idlers of the camp. At these she would occasionally hurl stones, being particularly hostile towards the negroes, who gave her a wide berth, to avoid the missiles, which she threw with considerable force and accuracy." This description presents the Confederacy as a grotesque, degraded female "specimen," an account continuous with Northern depictions of the white South as a world of gender reversal, filled with intemperate men and spiteful women.[34] Gardner further complicates such reversals with racial and ethnic designations, depicting an Irish Confederate woman attacking African American Union men. Since the Irish in nineteenth-century America were often aligned pejoratively with black people, the passage suggests multiple nonwhite actors.[35] The literary sketch sets in motion racial dramas that the photograph does not, locating its civil war between "negroes" who act defensively and "wild" Irish who aggress upon them.

Other literary sketches connote racial dramas metaphorically. *Army Repair Shop* (no. 70) depicts a bustling scene of tradesmen in army camp; neither the photograph nor its literary sketch, which has the more elaborate title *A Field Workshop in the Ninth Army Corps, before Petersburg,* mentions race. The sketch's descriptions of mule-shoeing, however, have racial connotations:

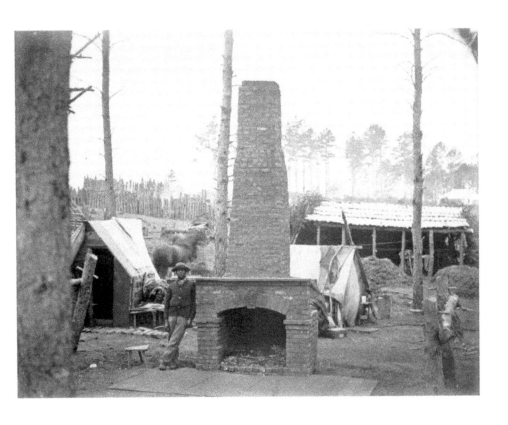

Figure 22 James Gardner, *Breaking Camp, Brandy Station* (no. 63 in the *Photographic Sketch Book*), 1864. Albumen print, 17.7 × 23.0 cm. Courtesy George Eastman House. Museum Collection.

On the right of the view is the stocks, a neat contrivance, to facilitate the shoeing of mules, an operation which those self-willed animals had a decided objection to undergo. . . . The refractory mule was led into the stocks. . . . Four stout fellows seizing his feet, fastened them securely with thongs in the required position, and while impotent rage convulsed his frame, rapidly nailed on the shoes, finally releasing the hybrid in a state of wretched uncertainty as to the intents and purposes of his masters.

Gardner offers a mini-narrative of power relations, wherein a "self-willed" and "refractory" figure is forced to assume "the required position," which fills him with "impotent rage" and leaves him "in a state of wretched uncertainty as to the intents and purposes of his masters." This is the contemporary language of mastery and enslavement; Gardner offers a staged ritual of discipline under slavery that resembles representations of slaves exhibited on auction blocks, paraded in chains, or whipped in front of others. The language of the passage also connotes racial mixture. The figure is a "hybrid" and a "mule," an animal linked to the term *mulatto* both etymologically and in other ways. This passage stages a symbolic scene of subjection, but it also suggests how strongly the "self-willed" mule, if his "impotent rage" were made potent, would resist "the intents and purposes of his masters."[36]

The sketches for *Quarles' Mill* and *A Field Workshop,* then, suggest how Gardner's words can introduce racial figures, literally or symbolically, when his images evacuate them. Four sketches in *Photographic Sketch Book* show the complex interaction between visual and verbal representations of race. First, *Slave Pen, Alexandria, Va.* (no. 2; figure 23) immediately follows *The Marshall House* and centers, like the previous image, on a building whose name is legible within the photograph, thereby offering an internal caption that implicitly anchors the sketch. Here, the name is "Price Birch & Co., Dealers in Slaves," an identification that unmistakably links the war to slavery. The names "Price" and "Birch" connote the money paid for slaves and the whips used to coerce them; they constitute a brief allegory of purchase and punishment within the photograph.

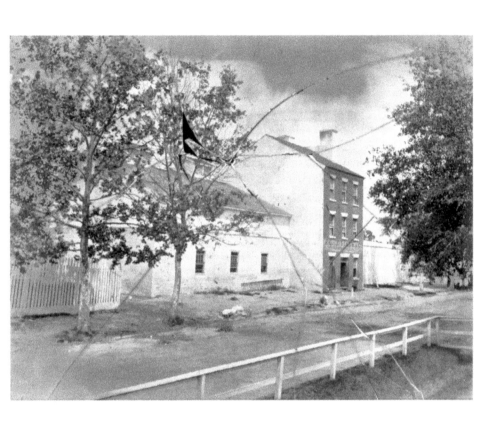

Figure 23 William Pywell, *Slave Pen, Alexandria Va.* (no. 2 in the *Photographic Sketch Book*), 1863. Courtesy of the Library of Congress.

The literary sketch specifies the building's function:

In many of the Southern cities the people had erected buildings of this kind for the confinement of slaves awaiting sale. The establishment represented in the photograph was situated in the western suburbs of Alexandria, near the depot of the Orange and Alexandria Railroad. The main building was used by the clerks of the firm and its overseers. The high brick wall enclosed a court yard, in which were stables and outhouses for the accommodation of planters who come in for the purpose of selling or purchasing slaves. The large building on the right was used for the confinement of the negroes. It had a number of apartments, in which the slaves could be kept singly or in gangs, and one large mess room, where they received their food. The establishment was essentially a prison. The doors were very strong, and were secured by large locks and bolts. Iron bars were fixed in the masonry of the windows, and manacles were frequently placed on the limbs of those suspected of designs for escape. Auction sales were regularly held, at which Virginia farmers disposed of their servants to cotton and sugar planters from the Gulf States. If a slave-owner needed money which he could not easily procure, he sold one of his slaves; and the threat of being sent South was constantly held over the servants as security for faithful labor and good behavior. Before the war, a child three years old, would sell, in Alexandria, for about fifty dollars, and an able-bodied man at from one thousand to eighteen hundred dollars. A woman would bring from five hundred to fifteen hundred dollars, according to her age and personal attractions.

The opening trajectory of this sketch echoes that of the previous one, from buildings to bodies: as *The Marshall House* moves from hotel to murdered man, so too does this sketch shift from slave pen to penned-up limbs. The first sentences also adapt a genealogy of abolitionist condemnations of the architecture of slavery. In *Uncle Tom's Cabin* (1852), for example, Harriet Beecher Stowe entitles a chapter "The Slave Warehouse" and describes it as "a house externally not much unlike many others, kept with neatness."[37] Stowe counterposes this deceptively ordered house to the cabin of Uncle Tom and other truly domestic spaces in the novel; Gardner's sketch provides no such refuges. Here, the slave warehouse follows the Marshall House, though in another sense pre-

ceding it: the "dingy hotel" debased by Confederates is built upon the foundational debasement of slavery.

Having moved from the outside to the inside of this building, Gardner journeys into further interiors of slavery. In *Uncle Tom's Cabin,* this journey is depicted in the novel's downward progression into the Deep South, from Kentucky to New Orleans and into the swamp plantation of Simon Legree. Gardner's southward progression is into the violated body, moving through the commodification of enslaved child, adult man, and adult woman, and ending with a phrase—"personal attractions"—that connotes the possibility of rape. So too does Stowe turn, in the later chapters of *Uncle Tom's Cabin,* to the plot of Cassy's sexual exploitation; in Jacobs's *Incidents in the Life of a Slave Girl,* in contrast, this theme is prominent from the start. At fifteen, her narrator remembers, "My master began to whisper foul words in my ear. . . . He peopled my young mind with unclean images, such as only a vile monster could think of. I turned from him with disgust and hatred."[38] "Attractions" was the last word of Gardner's literary sketch in *Slave Pen,* but the beginning of a well-established cultural narrative of exploitation. The sketch's movement into the interior of the building extends, ultimately, to the violation of African American women's bodies in slavery.

Unlike Jacobs and Stowe, Gardner does not provide a woman's account of this experience, and the hint of prurience created by the phrase "personal attractions" contrasts sharply with the volume's depictions of white women. They are shown in several photographs, such as *Camp Architecture* (no. 57) and *Aiken House, on Weldon Railroad, Va.* (no. 71), as stabilizing figures of femininity. The only visible woman of color in the *Photographic Sketch Book* appears in *Scene in Pleasant Valley Md.* (no. 24; figure 24), standing outside of a circle of white people; dressed as a servant, she is isolated from and subservient to the three white women in dresses who anchor its embodiment of home as "pleasant valley." In *Camp Architecture,* "the wives of officers, in their brief visits to the front, find a most pleasant abiding place, from which they return with reluctance to city homes." White women embody and occupy "pleasant abiding place[s],"

while the African American woman of *Slave Pen* is identified only by the prospect of her body's violation.

Slave Pen introduces the theme of slavery but identifies African Americans only as a faceless group; *What Do I Want, John Henry?* (no. 27; see figure 1) offers a detailed account of an African American man, here a "camp servant" to a Union army officer. The photograph depicts four uniformed white soldiers and an African American man, who holds food and drink. The long sketch that precedes this photograph merits quotation in its entirety:

When fatigued by long exercise in the saddle, over bottomless roads, or under the glowing Southern sun, John's master would propound the query, "What do I want, John Henry?" that affectionate creature would at once produce the demijohn of "Commissary," as the only appropriate prescription for the occasion that his untutored nature could suggest.

A legend was current at headquarters that J. H. had been discovered hanging by his heels to a persimmon tree. It is needless to state that this was a libel, originating in a scurrilous picture of that African, drawn by a special artist. In point of fact, he came into notice at Harrison's Landing, in the summer of 1862. An officer's hat blew off; John raised it, and with a grin (which alarmed the Captain, lest he should be held responsible if the head should fall off,) politely handed it up. The rare intelligence exhibited in this act naturally made a deep impression, and suggested an unusual capacity for the care of boots and other attentions, seldom rendered, although occasionally expected of camp servants. "Would you like to take service with me?" said the Captain. "Yees, sir," answered John. "Then follow me to camp." "I can't keep up, sir." "Catch hold of the horse's tail, then." In short, John Henry was installed body servant to Captain H–, quartermaster of headquarters, and took his position as an unmistakable character.

Although his head resembled an egg, set up at an angle of forty-five degrees, small end on top, yet his moral and intellectual requirements were by no means common. His appreciation of Bible history was shown on many occasions. For instance, he always considered Moses the most remarkable of quartermasters, in that he crossed the Red Sea without pontoons, and conducted the children of Israel forty years through the desert without a wagon train.

With wisdom such as this he would enlighten his sable compeers. Meanwhile, the Captain

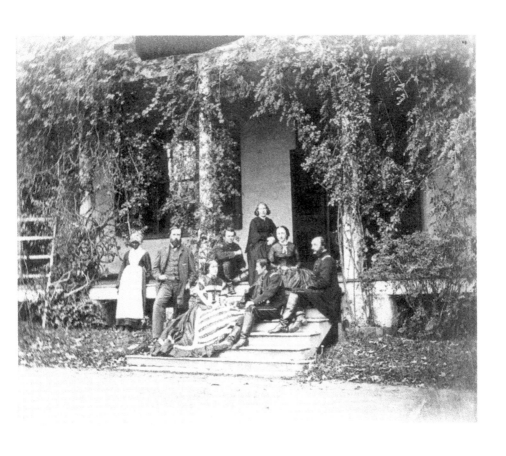

Figure 24 Alexander Gardner, *Scene in Pleasant Valley, Md.* (no. 24 in the *Photographic Sketch Book*), 1862. Courtesy of the Library of Congress.

became a Colonel. Richmond was evacuated, and John Henry became a resident of the rebel capital. Here freedom burst upon him in a new light; he formed new associations—principally with the other sex—to raise whose spirits he would appropriate his employer's. As his mind expanded, boots became monotonous, manual labor distasteful, and a dissolution of partnership inevitable. The Colonel went to another scene of duty. John Henry remained, whether owing to inducements offered by the Provisional Government is not yet definitely known.

This account is suffused with racist stereotypes: enslaved, John Henry is "untutored" and "affectionate"; in the army, he is a grinning figure suited to acts of servitude; as an "unmistakable character," he shows a childlike inability to distinguish between the characters of the Bible and army officers; and in Richmond, he becomes drawn toward women and alcohol. Simultaneously hypersexual and infantilized, John Henry is a fool whose characterization seems drawn from minstrelsy; the emphasis in the sketch on his entertainment value recasts the minstrel show in sketch form. With his egglike head, "small end on top," John Henry is also akin to a character in a freak show, a form of entertainment that often drew on racist images. With its lexicon of buffoonery, minstrelsy, and freakery, the literary sketch hyperbolically reinforces the disempowerment of John Henry shown in the photograph.[39]

Indeed, the literary sketch offers so much reinforcement of John Henry's visual servitude that it seems excessive. This is one of the longest of the sketches, overflowing with detail and plot, and the overflow exaggerates the hierarchies of the photograph to the point of destabilizing them. For example, the title of the sketch is the only one in question form, and it dramatizes the authority of the white man through hyperbole; not only must John Henry serve the white man, but he must also magically anticipate the man's desires. Similarly, if the photograph offers, as Alan Trachtenberg suggests, "the performance of a little scene between a master and a servant,"[40] then the literary sketch exaggerates this mode so that John Henry's servitude must be repeatedly performed. It is apparently not enough that John Henry be compared to an egg; he must

also be linked to a horse's tail and to boot cleaning—by implication, to the roles of horse's ass and bootlicker. Even the advent of freedom is presented as a fall into urban vice, into which he is symbolically seduced by the "inducements" of Confederates. This is a white fantasy about slavery and freedom, in which enslavement produces a slave who eagerly divines his master's wants, while freedom only sets him adrift.

Other writers in this era offered similarly hyperbolic scenes of black servitude in order to expose and invert them. In Herman Melville's *Benito Cereno* (1855), a white observer on board a ship is so accustomed to seeing black servitude that he fails to understand that a mutiny has taken place and a black man, Babo, now controls the ship's white captain, Benito Cereno. Watching Babo prepare to shave Cereno, Delano reflects: "There is something in the negro which . . . fits him for avocations about one's person. Most negroes are natural valets and hair-dressers. . . . There is, too, a smooth tact about them in this employment . . . singularly pleasing to behold, and still more so to be the manipulated subject of."[41] The irony is cutting: Delano himself is the "manipulated subject," while Babo, rather than being a "natural valet," is Cereno's potential executioner. In Melville's novella, stereotypes about black servitude make the white viewer so blind that they provide an excellent cover for black mutiny.

While the reversals in Gardner's depiction of John Henry are not as obvious, there are several discordant elements in the sketch that unsettle its racial hierarchies. Gardner provides an image of artistic misrepresentation near the outset: the legend that "J. H. had been discovered hanging by his heels to a persimmon tree. It is needless to state that this was a libel, originating in a scurrilous picture of that African, drawn by a special artist." This passage, highlighting the likelihood that black men are misrepresented, throws Gardner's own account into question; perhaps it too is a "scurrilous picture." The discovery of John Henry hanging from a tree presumably turns on a racist comparison of black people with monkeys, but it also connotes lynching, which would become a major instrument of racial terror in the postwar period. This

image, in turn, rhymes with that of the Captain who, on seeing John Henry grinning, is "alarmed . . . lest he should be held responsible if the head should fall off." Again, the tone is ostensibly comic, but the racist stereotype—John Henry's grin is so wide that it seems to separate his head from his body—offers another image of a black man's violent death, for which the white officer might be "held responsible." These images create a gothic narrative in which racial hierarchy is so violently enforced that its trail leads to decapitated black men, and then back to white men. Finally, the proper name of the sketch tantalizingly evokes a tradition of black heroism. By the 1880s, "John Henry" would be famous as the name of a black folk hero, a steel driver so strong that he outpowers a steam drill, defeating his human bosses as well as their machines. This folklore postdates Gardner's volume, but only slightly—the original John Henry may have been a Union army laborer—and it saturates the name for readers in subsequent generations.[42] Even if he is not linked to the heroic John Henry of folklore, Gardner's John Henry is, significantly, missing in Richmond at the end of the sketch. His "expanded" thoughts are "not yet definitely known," out of the reach of a narrator who can imagine him only in the performance of servitude.

While *What Do I Want, John Henry?* highlights the hierarchical relationship between a black servant and his white master, *A Fancy Group, Front of Petersburg* (no. 76; figure 25) suggests the social dynamics—including potentially erotic ones—between groups of white and black men. The photograph depicts two black men, in profile, on their knees, holding cocks that they are poised to release for a fight; they are surrounded by eleven white men. The racial asymmetries of the photograph are spatially organized, with white men sitting and standing above black men. This arrangement is continuous not only with the history of minstrelsy, in which black men performed for white audiences, but also with an established abolitionist iconography of black men on their knees before white men in pleas for sympathy, and with an emerging postwar vocabulary of war memorialization featuring standing soldiers and kneeling slaves.[43]

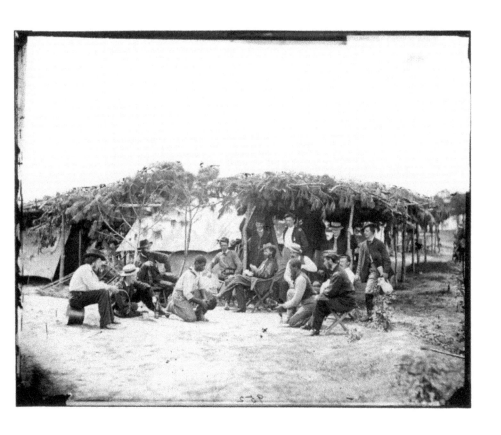

Figure 25 David Knox, *A Fancy Group, Front of Petersburg* (no. 76 in the *Photographic Sketch Book*), 1864. Courtesy of the Library of Congress.

The literary sketch narrates these hierarchies:

The monotony of camp life was relieved by every variety of amusement that was known, or could be devised. During the periods of inactivity, base ball, cricket, gymnastics, foot races, & c., were indulged in to a great extent, and on holidays horse races, foot races, and other games were allowed. Sometimes the men would put up a greased pole, with a prize on the top, for any one who succeeded in climbing up to it, and not unfrequently a pig would be turned loose with a shaved and greased tail, for the men to catch. Any grip but a "tail hold" was illegitimate, but he who seized and held the pig by this appendage, carried it off in triumph to his mess.

 Cock fighting, however, was quite unusual, and seldom permitted, except when some of the contrabands incited their captured Shanghais, or more ignoble fowls, to combat. Such displays were always ludicrous, and were generally exhibited for the amusement of the mess for whom the feathered bipeds were intended. Horses and mules perished by hundreds from ill-usage, but with this exception it would be exceedingly difficult to cite an instance of cruelty to animals in the army. Fowls, dogs, kittens, and even wild animals, were made pets of, and were cared for most tenderly. Sometimes a regiment would adopt a dog, and woe to the individual who ventured to maltreat it. Several of the Western regiments carried pet bears with them, and one regiment was accompanied by a tame eagle in all its campaigns.

The sketch names the black men only as "contrabands," the term given to escaped slaves who were considered property of the Union army and thus could not be returned to slavery. The term was controversial; for example, in 1862, Frederick Douglass criticized the federal government because it "only sees in the slave an article of commerce—a contraband."[44] Gardner, by contrast, increases the dehumanizing effects of the term, submerging "contrabands" in lists of "amusements" and animals. The image of John Henry grabbing on to the horse's tail has become that of unnamed contrabands immersed in a world of pigs, horses, fowls, dogs, kittens, and bears. This world includes even the eagle, who ordinarily connoted freedom, especially as a national emblem. In a world in which even the American eagle is tamed, the cockfighting contra-

bands become two more members of a menagerie of pets so domesticated as to be enslaved.

Within this menagerie, however, the sketch also provides a vocabulary for the potential homoeroticism of the photograph. The Civil War afforded new opportunities for the experience and representation of intimacy between men, a possibility signaled most eloquently by the poetry of Walt Whitman, in lines such as "Many a soldier's loving arms about this neck have cross'd and rested, / Many a soldier's kiss dwells on these bearded lips."[45] Gardner photographed Whitman, and Whitman later praised him as "a mighty good fellow—also mightily my friend: he was always loving: I feel near to him—always—to this day."[46] In the *Photographic Sketch Book,* Gardner's thematic proximity to Whitman is strongest in the photograph that ends the first volume, *The Halt* (no. 50; figure 26), in which two men lounge in an open field, one looking at the other, beside a gleaming horse. As a depiction of relations between men, the photograph suggests great intimacy, if not also homoeroticism. The "halt" of its title seems not only a cessation of military activity but also an interruption of the more conventional experience of the body in wartime as a site of pain, and of the sexual narratives of wartime wherein soldiers return to the "pleasant valleys" of their wives when fighting is over.

The sketch for *A Fancy Group* invokes intimacy between men configured, hierarchically, across race. Elsewhere in Civil War literature, white men represented black men in ways that emphasized their physical beauty. For example, Thomas Wentworth Higginson wrote voyeuristically of the regiment of black soldiers he commanded, "I always like to observe them when bathing,—such splendid muscular development," and praised his color-sergeant for being "jet black, or rather, I should say, *wine-black;* his complexion, like that of others of my darkest men, having a sort of rich, clear depth, without a trace of sootiness, and to my eye very handsome."[47] Gardner does not focus on muscles and complexions, but his photograph, too, shows white men looking intently at black men. Since *cock,* then as now, could be a synonym for *penis,* it is possible to think of the word as having sexual connotations in the sketch. The

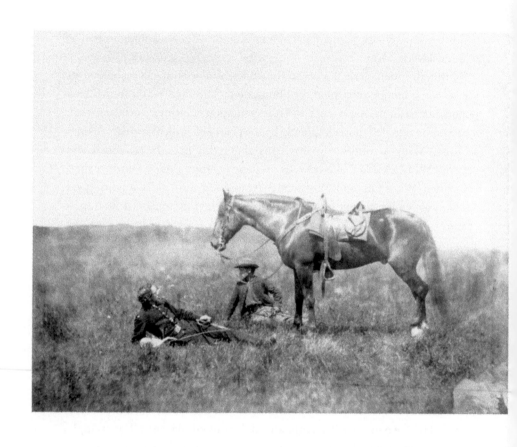

Figure 26 Timothy H. O'Sullivan, *The Halt* (no. 50 in the *Photographic Sketch Book*), 1864. Albumen print, 17.8 × 23.0 cm. Courtesy George Eastman House. Museum Purchase.

sketch supplies the word as the photograph does not, thereby giving the sexual connotations of the visual image a possible name. The profusion of synonyms that follow—"captured Shanghais," "ignoble fowls," and "feathered bipeds"— only serves to highlight the particularity of "cock," unmodified, at the start of the paragraph.

Preceding this word is another suggestive passage: the description of the "pig . . . turned loose with a shaved and greased tail, for the men to catch[;] . . . he who seized and held the pig by this appendage, carried it off in triumph." Sexual implications again seem possible in a scene of humans forcibly manipulating animals. Gardner's imagery is that of men in pleasurable pursuit of a "shaved and greased" body part, holding "this appendage . . . in triumph"; this description stresses bodies in pleasurable movement, connoting, perhaps, both masturbation and same-sex contact. Together, these literary images of men cockfighting and lunging for greased pigs seem to suggest an eroticized space in which bodily boundaries erode, visually and physically if not also sexually. The flow of the sketch firmly submerges "contrabands" in the racist hierarchies of slavery, but it also gives a name and a narrative frame for the potentially intimate relation of white to black male bodies in a Civil War setting.

In *What Do I Want, John Henry?* and *A Fancy Group, Front of Petersburg* black men are shown in profile, their gazes hidden; in *A Burial Party, Cold Harbor, Va.* (no. 94; see figure 2), both the literary sketch and photograph bring this gaze into view. The photograph depicts four African American men collecting body parts on a battlefield and a fifth sitting alongside a cart of skeletons, looking directly at the camera. Black men in the Union army were frequently assigned burial detail, assembling remains and digging trenches for graves; such duties accorded with the inequitable treatment they received from the military in other ways, such as lower pay.[48] However, the photograph also works against such inequities, in its presentation of the seated man. As in *Breaking Camp,* a black man looks directly at the camera, and here his gaze bears witness to the grim and grueling labor he and the other black men perform.

The literary sketch both diminishes and intensifies the racial dimensions of looking:

This sad scene represents the soldiers in the act of collecting the remains of their comrades, killed at the battles of Gaines' Mill and Cold Harbor. It speaks ill of the residents of that part of Virginia, that they allowed even the remains of those they considered enemies, to decay unnoticed where they fell. The soldiers, to whom commonly falls the task of burying the dead, may possibly have been called away before the task was completed. At such times the native dwellers of the neighborhood would usually come forward and provide sepulture [the act of burying the dead] for such as had been left uncovered. Cold Harbor, however, was not the only place w[h]ere Union men were left unburied. It was so upon the field of the first Bull Run battle, where the rebel army was encamped for six months afterwards. Perhaps like the people of Gettysburg, they wanted to know first "who was to pay them for it." After that battle, the soldiers hastened in pursuit of the retiring columns of Lee, leaving a large number of the dead unburied. The Gettysburgers were loud in their complaints, and indignantly made the above quoted inquiry as to the remuneration, upon being told they must finish the burial rites themselves.

Among the unburied on the Bull Run field, a singular discovery was made, which might have led to the identification of the remains of a soldier. An orderly turning over a skull upon the ground, heard something within it rattle, and searching for the supposed bullet, found a glass eye.

This sketch is particularly digressive, its first paragraph taking a contorted route toward a condemnation of Confederates who are "[p]erhaps like the people of Gettysburg [who] wanted to know first 'who was to pay them for it.'" The second paragraph, however, offers a single, focused anecdote: "An orderly turning over a skull upon the ground, heard something within it rattle, and searching for the supposed bullet, found a glass eye." As an image of looking, the eye seems triply disabled: by its replacement with glass, by the death of its corporeal host, and by its dismemberment from the face after the flesh's dissolution. In the most famous image of an eye in nineteenth-century American literature, the disembodied eyeball is all-powerful: "Standing on the

bare ground,—my head bathed by the blithe air, and uplifted into infinite space,—all mean egotism vanishes. I become a transparent eye-ball. I am nothing. I see all."[49] Emerson's eyeball is transparent, transcendent, and lifted up into "blithe air." Gardner's eye, by contrast, is opaque, degraded, and thrown to the ground within an unseeing skull.

Yet what this eye lacks in transcendence, it gains in gothic power. The eye is literally unseeing, but metaphorically potent: in the moment when the orderly hears but cannot identify it, it seems as powerful and piercing as a bullet. The loud, mobile glass eye is racially marked as well. Neither the race of the "orderly" nor that of the skull is named in the sketch, but since the men gathering remains in the photograph are African American, it seems likely that the orderly in the sketch is as well. Juxtaposed with the photograph, the literary image of the glass eye strengthens the confrontational challenge evident in the powerful gaze of the live man. Not only does this man bear witness to the labor of his comrades, but his gaze also extends the bulletlike force of the glass eye and the haunting memory of black bodies killed in slavery as well as wartime. Dead and alive, the eyes of the sketch and photograph together suggest the power in and of black spectatorship.[50]

The photograph's eyes are, in turn, linked to its dismembered foot. Civil War literature frequently connected the severed limbs of the soldier with the severed body politic, and the industry of prosthetic limbs that developed during this time advertised its products in terms of national as well as individual reconstruction.[51] The shoe-clad foot, added by Gardner to the scene for dramatic effect, dominates the center of this image, and we can interpret its centrality as symbolic of the fractures of the nation. The profusion of skulls indicates the extent of Civil War death, while the foot, still in its shoe, suggests a recently dismembered body.

The foot is also part of a circuitry of racial imagery. Connections between feet and slaves were made elsewhere in Civil War commentary; in an essay on artificial limbs and the war, for example, Oliver Wendell Holmes remarks, "The foot's fingers are the slaves in the republic of the body. . . . They bear the

burdens, while the hands, their white masters, handle the money and wear the rings. . . . As a natural consequence of all this, their faculties are cramped, they grow into ignoble shapes, they become callous by long abuse, and all their natural gifts are crushed and trodden out of them."[52] In Gardner's photograph, the dismembered foot seems an extension of the live African American bodies. The foot is flanked by the four sets of embodied feet belonging to the men standing in the background, while the man seated at the left has only one boot visible, to which the dismembered one seems a twin.[53] The black man at the left is the "slav[e] in the republic of the body," perhaps literally once a slave, certainly now low in the army hierarchy—a symbolic foot soldier. Assigned to corpses, he is so far from the head of the body politic that he is pushed to its extremities and severed from it—decapitated, as it were, from below.

At the same time, the severed foot, like the glass eye, connotes potential resistance. If we interpret the foot in the photograph as belonging to a white man, then it anchors a reversal of Holmes's model of the black foot as subject to the white hand. In April 1865, with the war over and the slave emancipated, the black hand is—at least at this moment—master of the white foot. Foot, hand, eye: *A Burial Party* offers a gothic relay among dismembered body parts and between words and images. In this relay is the potential for a new kind of embodiment, individual and national, centered on African Americans. In the photographic image of the black man's gaze, and even more in the literary image of the rattling eye, is the promise of a query unasked elsewhere in the volume. What does John Henry want?

GARDNER'S *Photographic Sketch Book* ends with *Dedication of Monument on Bull Run Battle-Field* (no. 100; figure 27). This photograph depicts a crowd in front of a large stone monument, on which the words "To the Memory of the Patriots" are visible. This internal caption complements those in photographs earlier in the volume, while also signaling the emergence of a major new form of Civil War imagetext: the inscribed stone monument, whose words ranged from simple and declarative to long and rhetorically elaborate.[54] In other ways,

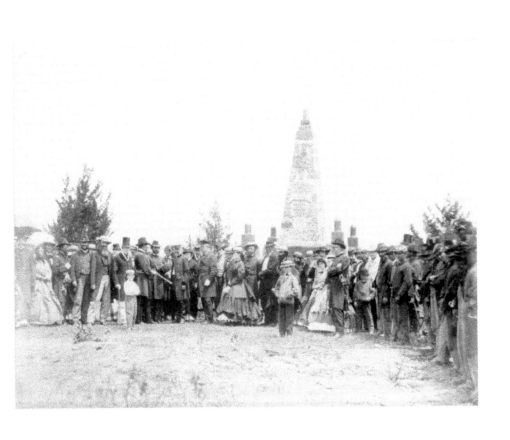

Figure 27 W. Morris Smith, *Dedication of Monument on Bull Run Battle-Field* (no. 100 in the *Photographic Sketch Book*), 1865. Courtesy of the Library of Congress.

however, this photograph differs sharply from those in the rest of the volume. Compared with the stasis and emptiness of many of the other images, it is dynamic, filled with movement; people loom larger than buildings and spill over the edges of the frame. At least three white women are present, the one in profile near the center apparently caught in movement. White women led many campaigns for Civil War memorialization, and here their visibility and mobility contrast with the earlier photographs in which they figure as static domestic icons.

Yet the sketch is extremely static:

Here is shown one of the Monuments erected in memory of the Union dead who fell at the battles of Bull Run and Groveton. The Monuments are of chocolate colored sandstone, twenty-seven feet high, and were erected by the officers and men of General Gamble's separate cavalry brigade, camped at Fairfax Court-House. The Monument on the first Bull Run field is situated on the hill in front of the memorable stone house, on the spot where the 14th Brooklyn, 1st Michigan, and 1st and 2d Maine were most hotly engaged, and where Ricketts and Griffin lost their batteries. The shaft is twenty-seven feet high, and bears upon its top a hundred pound shell. On the pedestal at each corner is a shell of similar size. On one side of the shaft is inscribed, "To the memory of the patriots who fell at Bull Run, July 21st, 1861," and on the reverse, "Erected June 10th, 1865." The Monument at Groveton is similar in its proportions, bearing the inscription, "To the memory of the patriots who fell at Groveton, August 29, 1862," and on the reverse also, "Erected June 10, 1865."

The dedicatory exercises were conducted on the first Bull Run field, by Rev. Dr. McMurdy, who read an appropriate service, which was followed by a hymn written for the occasion by Pierpont, a military parade by the 5th Pennsylvania Heavy Artillery, Colonel Gallup, and a salute by the 16th Massachusetts Battery, Captain Scott. At the close of these ceremonies, eloquent addresses were delivered by Judge Olin, General Wilcox, General Heintzelman, and General Farnsworth. At the second Monument the services were similar to those described.

This description returns to the beginning of the *Photographic Sketch Book* in stabilizing ways. We are back in northern Virginia, now reclaimed for the

Union, and back to 1861, just after the Ellsworth episode. Gone is the looting frenzy of "relic hunters"; here, memorialization involves the dedication of monuments in an orderly ritual structured by speeches, hymns, and salutes. The partisanship that triggered the Ellsworth episode now goes unmentioned, even though the very name "Bull Run" was contested territory, since Confederates called this battle Manassas. Effacing partisan conflict, the sketch also omits women, and it further emphasizes masculinity symbolically, in its attention to the size of the monument's shaft and its date of erection.

As for the horrors of the slave pen, they appear nowhere in the sketch. The photograph seems to represent only white people, and so too does the sketch ignore African Americans; the avenues of connotation and metaphor through which other sketches in the volume mark race are absent here. In this erasure of race, Gardner was not alone: monuments to the war, and its public memory in general, quickly moved away from slavery and toward a narrative of white reconciliation. By the turn of the century, most accounts of the Civil War would be whitewashed, in an era dominated by lynching, Jim Crow segregation, and the birth of *Birth of a Nation* (1915).[55] Griffith's racist film would become the dominant photographic sketchbook of the Civil War, with individual images edited into cinematic narrative and verbal text transmuted into intertitles—new forms of imagetext openly enlisted in the service of the Confederacy and the Ku Klux Klan.

And yet: Gardner's final literary sketch is set on the ground of Bull Run, and that same ground, in the sketch for *A Burial Party,* was the site of the "singular discovery" of the glass eye rattling in the skull. That unburied eye constitutes an alternate Civil War monument, less famous than those at Bull Run but richer in metaphoric possibilities. It gestures toward the haunting and unfinished racial legacy of the war, and it stands, too, as an emblem of the evocative possibilities of the sketchbook form. Surveying his sketchbook, Irving had written, the artist finds that his pages are "crowded with . . . obscure ruins; but he had neglected to paint St. Peter's." In Gardner's *Photographic Sketch Book,* a secular version of St. Peter's appears, in the form of the Bull Run

monument. But the "obscure ruin" of the unburied glass eye remains a more powerful testament, unmonumentalized, to the power of Gardner's own unburied eye.

One final passage, from another of Gardner's sketches, provides a further alternative to the orderly reading of speeches and hymns with which the volume's last sketch ends. In *Old Capitol Prison, Washington* (no. 90), Gardner details restrictions on reading for Confederate prisoners:

The regulations required that all correspondence and reading matter . . . should be closely scrutinized. . . . Underscoring words in books, at long intervals, so that when taken together they would embody a sentence, was not unusual with the prisoners when about to return to their friends volumes that had been loaned them for perusal. The latter occasioned considerable labor to the officers of the prison, every book going to or from the inmates being carefully examined, not only for messages of this kind, but for communications that might be concealed between leaves pasted together.

This passage draws attention to the importance of reading the words of the Civil War in fresh ways. In this case, that involves finding new meanings constructed from words disguised not by concealment but by distance, "so that when taken together they would embody a sentence." For prisoners, this technique turns preexisting sentences—penal and literary—into urgent code and situates readers as important allies and combatants. I have approached the *Photographic Sketch Book* with similar attention to its writing, underscoring words in the volume and connecting literary sketches far apart in the text. As for the final image in this paragraph, that of "leaves pasted together," it is worth remembering that Gardner's photographs were developed in a wet-plate process on glass coated with collodion. Understanding Gardner's photographs means looking at, rather than through, the pages of words with which they are interleaved. What else can we read in the words between Gardner's leaves of glass?

We thank Stephanie Fay and Eric Schmidt at the University of California Press for their hard work and support in publishing this book; Alice Falk for her sharp copyediting; the two anonymous readers for UC Press for their incisive comments; and the librarians at the Library of Congress, the New York Public Library, and the University of Pennsylvania for facilitating our research. In addition, Anthony Lee would like to thank Barbara Galasso and Barbara Moore, and Elizabeth Young would like to thank Faith Barrett, Chris Benfey, Bettina Bergmann, Anna Botta, William Cohen, Laura Green, Bruce Hay, Barbara Kellum, and Dana Leibsohn.

Introduction

1. A word about titles. The original 1866 publication of Gardner's book was called *Gardner's Photographic Sketch Book of the War*. All of the original editions we consulted carry that title. The 1959 Dover reprint changed the title to *Gardner's Photographic Sketch Book of the Civil War*. The 2001 Delano Greenidge reprint changed the title yet again, to *Gardner's Photographic Sketch Book of the American Civil War, 1861–1865*. To try to avoid complications, we use the simpler *Photographic Sketch Book* to name Gardner's book, understanding full well that no such work with that specific title was ever published. To simplify photograph titles, we omit dates that Gardner sometimes appended to his captions.

2. For analyses of Gardner's Civil War photographs, see Michael L. Carlebach, *The Origins of Photojournalism in America* (Washington, D.C.: Smithsonian Institution Press, 1992), 62–101; Keith F. Davis, "'A Terrible Distinctness': Photography of the Civil War Era," in *Photography in Nineteenth-Century America*, ed. Martha A. Sandweiss (Fort

Worth, Tex.: Amon Carter Museum, 1991), 130–79; D. Mark Katz, *Witness to an Era: The Life and Photographs of Alexander Gardner* (Nashville, Tenn.: Rutledge Hill Press, 1991); Geoffrey Klingsporn, "Icon of Real War: *A Harvest of Death* and American Photography," *Velvet Light Trap*, no. 45 (Spring 2000): 4–19; Franny Nudelman, *John Brown's Body: Slavery, Violence, and the Culture of War* (Chapel Hill: University of North Carolina Press, 2004), 103–31; Shirley Samuels, *Facing America: Iconography and the Civil War* (New York: Oxford University Press, 2004), 70–74; William F. Stapp, "'Subjects of Strange . . . and of Fearful Interest': Photojournalism from Its Beginnings in 1839," in *Eyes of Time: Photojournalism in America,* ed. Marianne Fulton (Boston: Little, Brown, 1988), 1–33; Stapp, "'To . . . Arouse the Conscience, and Affect the Heart': America and the Civil War," in *An Enduring Interest: The Photographs of Alexander Gardner,* ed. Brooks Johnson (Norfolk, Va.: Chrysler Museum, 1991), 17–57; Timothy Sweet, *Traces of War: Poetry, Photography, and the Crisis of the Union* (Baltimore: Johns Hopkins University Press, 1990), 107–37; Alan Trachtenberg, *Reading American Photographs: Images as History, Mathew Brady to Walker Evans* (New York: Hill and Wang, 1989), 71–118; and Megan Rowley Williams, *Through the Negative: The Photographic Image and the Written Word in Nineteenth-Century American Literature* (New York: Routledge, 2003), 61–97. In contrast to the relatively limited materials on Gardner's pictures, the literature on Brady's is substantial. For an introduction, see Mary Panzer, *Mathew Brady and the Image of History* (Washington, D.C.: Smithsonian Institution Press, 1997).

The Image of War / Anthony W. Lee

1. On the book's foundational status, see William E. Stapp, "'Subjects of Strange . . . and of Fearful Interest': Photojournalism from Its Beginnings in 1839," in *Eyes of Time: Photojournalism in America,* ed. Marianne Fulton (Boston: Little, Brown, 1988), 28; Stapp, "'To . . . Arouse the Conscience, and Affect the Heart': America and the Civil War," in *An Enduring Interest: The Photographs of Alexander Gardner,* ed. Brooks Johnson (Norfolk, Va.: Chrysler Museum, 1991), 28; and Jefferson Hunter, *Image and Word: The Interaction of Twentieth-Century Photographs and Texts* (Cambridge, Mass.: Harvard University Press, 1987), 3.

2. As far as I know, Gardner was never directly involved in any case concerning patents and copyright, but he certainly knew of many, including those related to his business partners, the Anthony brothers of New York. For an example of their many

patent-related efforts, see "The Fredricks' Fund," *Humphrey's Journal* 12, no. 2 (May 1860): 17–18. The call for a school, including the suggestion to make photography a permanent course of instruction in the military academies, never amounted to anything more substantive. Marcus Root was usually at the center of these several efforts. See, for example, his articles "Heliographic Schools," *Humphrey's Journal* 12, no. 3 (June 1860): 33–34, and "Heliography in Our Military Schools," *Humphrey's Journal* 12, no. 9 (September 1860): 134–36.

3. Keith F. Davis, "'A Terrible Distinctness': Photography of the Civil War Era," in *Photography in Nineteenth-Century America,* ed. Martha A. Sandweiss (Fort Worth, Tex.: Amon Carter Museum, 1991), 144.

4. William A. Frassanito, *Early Photography at Gettysburg* (Gettysburg, Pa.: Thomas Publications, 1995), 26–54.

5. Any kind of coverage of the war—literary, photographic, illustrative—was generally a Northern prerogative. On the popular literary side, see Alice Fahs, *The Imagined Civil War: Popular Literature of the North and South, 1861–1865* (Chapel Hill: University of North Carolina Press, 2001). On the illustrative, see William Fletcher Thompson, *The Image of War: The Pictorial Reporting of the American Civil War* (New York: Thomas Yoseloff, 1959).

6. On Homer's Civil War images, see Nikolai Cikovsky, Jr., "The School of War," in Cikovsky and Franklin Kelly, *Winslow Homer* (Washington, D.C.: National Gallery of Art; New Haven: Yale University Press, 1995), 17–37. See also Marc Simpson et al., *Winslow Homer: Paintings of the Civil War* (San Francisco: Fine Arts Museum of San Francisco, 1988).

7. William Campbell, *The Civil War: A Centennial Exhibition of Eyewitness Drawings* (Washington, D.C.: National Gallery of Art, 1961), 47.

8. George Augustus Sala, *My Diary in America in the Midst of War* (London: Tinsley Brothers, 1865), 1:302–3.

9. Although Gardner's work for the Topographical Engineers is often cited, I know of no surviving examples of his photographs of maps and military documents. One photograph by Gardner, sometimes dated to 1862 and said to include Gardner's son, Lawrence, shows the large-view camera and vertical plank used to copy and enlarge documents.

10. William Waud, *Frank Leslie's Illustrated News,* May 17, 1862.

11. Gardner's capture is alluded to in the caption for his stereoview no. 228 of

Farmer's Inn in Emmitsburg, Maryland, a photograph taken during a stopover on his way to Gettysburg, but it remains a matter of some dispute. D. Mark Katz accepts the claim (see *Witness to an Era: The Life and Photographs of Alexander Gardner* [Nashville, Tenn.: Rutledge Hill Press, 1991], 61), but William A. Frassanito qualifies it (see *Gettysburg: A Journey in Time* [New York: Scribner's, 1975], 26–27).

12. Gardner and Gibson made ninety-five Antietam images in all, fifty within the first five days after the battle and twenty-five more several weeks later when Lincoln visited McClellan in the field. On Gardner's movements at Antietam and the general sequence of pictures, see William A. Frassanito, *Antietam: The Photographic Legacy of America's Bloodiest Day* (New York: Scribner's, 1978).

13. George N. Barnard, *Photographic Views of Sherman's Campaign,* new preface by Beaumont Newhall (1866; reprint, New York: Dover, 1977). See also Keith F. Davis, *George N. Barnard: Photographer of Sherman's Campaign* (Kansas City, Mo.: Hallmark Cards, 1990).

14. Theodore Davis, "How a Battle Is Sketched," *St. Nicholas* 16, no. 2 (1889): 662.

15. Gardner's captions in the Antietam series of photographs, especially stereo-card no. 671, suggest he was on the spot on September 17, 1862, but William A. Frassanito, who has examined the evidence most closely, is not persuaded (see *Antietam: The Photographic Legacy of America's Bloodiest Day* [New York: Scribner's, 1978], 71–73).

16. See, of course, Roland Barthes, *Camera Lucida: Reflections on Photography,* trans. Richard Howard (New York: Farrar, Straus and Giroux, 1981).

17. I am practically quoting Barthes verbatim on these aspects of photography (see *Camera Lucida,* 78–80).

18. Orville Victor, *The History, Civil, Political and Military, of the Southern Rebellion, from Its Incipient Stages to Its Close,* vol. 1 (New York: James D. Torrey, 1861), iii.

19. *Frank Leslie's Pictorial History of the American Civil War* (New York: Frank Leslie's, 1862).

20. On the market for these many publications, see Fahs, *Imagined Civil War,* 287–310.

21. The serial began in 1866 as *Harper's Pictorial History of the Great Rebellion in the United States* (New York: Harper and Brothers, 1866). Its name soon became *Harper's Pictorial History of the Civil War,* under which title the entire serial was reprinted both in the late nineteenth century and in the twentieth century.

22. Benson J. Lossing, *Pictorial History of the Civil War,* 3 vols. (Philadelphia: G. W. Childs, 1866–68). This history proved so popular that Lossing republished it several years later under a slightly modified title, *Pictorial Field Book of the Civil War.*

23. Headley, *The Great Rebellion,* 71–75.

24. "Brady's Photographs: Pictures of the Dead at Antietam," *New York Times,* October 20, 1862.

25. "Scenes on the Battlefield of Antietam," *Harper's Weekly,* October 18, 1862, 663–65.

26. Oliver Wendell Holmes, "Doings of the Sunbeam," *Atlantic Monthly* 12 (July 1863): 12; the reference to the Antietam photographs forms a small but traumatic part of Holmes's essay, which is well worth reading in its entirety (1–17).

27. The more familiar version (see figure 13) is included in the *Sketch Book* at the University of Pennsylvania, the copy used as the basis for the popular Dover Press reissue. Yet in examining other original copies of the *Sketch Book*—for example, at the Library of Congress and the New York Public Library—I have more often encountered figure 15. It is that second version that appears (inaccurately, in reverse) in the most recent reprint of the *Sketch Book,* published in 2001 by Delano Greenidge.

28. James M. McPherson, *Battle Cry of Freedom: The Civil War Era* (New York: Oxford University Press, 1988), 734.

29. On the importance of burial and the *Photographic Sketch Book*'s relation to it, see Franny Nudelman, *John Brown's Body: Slavery, Violence, and the Culture of War* (Chapel Hill: University of North Carolina Press, 2004), 103–31. See also John R. Neff, *Honoring the Civil War Dead: Commemoration and the Problem of Reconciliation* (Lawrence: University Press of Kansas, 2005).

30. For a general discussion of the appearance of the themes of slavery and emancipation during Reconstruction, see David W. Blight, *Race and Reunion: The Civil War in American Memory* (Cambridge, Mass.: Harvard University Press, 2001). For a discussion of their complicated imagery, see Kirk Savage, *Standing Soldiers, Kneeling Slaves: Race, War, and Monument in Nineteenth-Century America* (Princeton: Princeton University Press, 1997).

31. Joseph M. Wilson, *A Eulogy on the Life and Character of Alexander Gardner* (Washington, D.C.: Lebanon Lodge, 1883), 10. Wilson addressed his eulogy to members of the Lebanon Lodge, a mutual aid society, but portions of it were also reprinted in *The Philadelphia Photographer* (20 [January 1883]: 92–95), including the paragraph I quote.

32. A few scholars have compared Gardner's and Barnard's albums. See, for example, Alan Trachtenberg, *Reading American Photographs: Images as History, Mathew Brady to Walker Evans* (New York: Hill and Wang, 1989), 71–118, and Megan Rowley Williams, *Through the Negative: The Photographic Image and the Written Word in Nineteenth-Century American Literature* (New York: Routledge, 2003), 61–97.

Verbal Battlefields / Elizabeth Young

1. These extremes are, respectively, *Johnson's Mill, Petersburg, Virginia* (no. 80) and *Field Telegraph Battery Wagon* (no. 73). Little is known about the composition of the texts in the volume, but Gardner apparently wrote them all; see E. F. Bleiler, introduction to *Gardner's Photographic Sketchbook of the Civil War* (1866; reprint, New York: Dover, 1959), [3]. All subsequent quotations are taken from the Dover edition and cited by title—a more complicated matter than it might seem. There are several kinds of titles in the volume: those atop the written texts differ from those below the photographs, while the latter also vary typographically from copy to copy (some incorporate the date on the same line, while others relegate this information to the corner). Throughout this essay, I have used the title given to the literary text unless otherwise specified.

2. George N. Barnard, *Photographic Views of Sherman's Campaign,* new preface by Beaumont Newhall (1866; reprint, New York: Dover, 1977); the pamphlet is reproduced on ix–xviii. For discussion of Barnard, see Keith F. Davis, *George N. Barnard: Photographer of Sherman's Campaign* (Kansas City, Mo.: Hallmark Cards, 1990); Timothy Sweet, *Traces of War: Poetry, Photography, and the Crisis of the Union* (Baltimore: Johns Hopkins University Press, 1990), 138–64; and Alan Trachtenberg, *Reading American Photographs: Images as History, Mathew Brady to Walker Evans* (New York: Hill and Wang, 1989), 99–107.

3. "Photographic History of the War," advertisement quoted in D. Mark Katz, *Witness to an Era: The Life and Photographs of Alexander Gardner* (Nashville, Tenn.: Rutledge Hill Press, 1991), 89.

4. The staging was first exposed by William A. Frassanito, *Gettysburg: A Journey in Time* (New York: Scribner's, 1975); for recent commentary on it, see Susan Sontag, *Regarding the Pain of Others* (New York: Farrar, Straus and Giroux, 2003), 51–55.

5. No critic seems to have remarked on this aspect of the original book. The assumption is, rather, that "Gardner places an extended caption opposite each image" (Trachtenberg, *Reading American Photographs,* 95).

6. The "purple prose" characterization is in Michael L. Carlebach, *The Origins of Photojournalism in America* (Washington, D.C.: Smithsonian Institution Press, 1992), 87. For other considerations of Gardner's written text, see Keith F. Davis, "'A Terrible Distinctness': Photography of the Civil War Era," in *Photography in Nineteenth-Century America,* ed. Martha A. Sandweiss (Fort Worth, Tex.: Amon Carter Museum, 1991), 168; Shirley Samuels, *Facing America: Iconography and the Civil War* (New York: Oxford University Press, 2004), 70–71; and Trachtenberg, *Reading American Photographs,* 96–99. On the volume as a foundational photo-essay, see William F. Stapp, "'Subjects of Strange . . . and of Fearful Interest': Photojournalism from Its Beginnings in 1839," in *Eyes of Time: Photojournalism in America,* ed. Marianne Fulton (Boston: Little, Brown, 1988), 23; Stapp, "'To . . . Arouse the Conscience, and Affect the Heart': America and the Civil War," in *An Enduring Interest: The Photographs of Alexander Gardner,* ed. Brooks Johnson (Norfolk, Va.: Chrysler Museum, 1991), 28; and Jefferson Hunter, *Image and Word: The Interaction of Twentieth-Century Photographs and Texts* (Cambridge, Mass.: Harvard University Press, 1987), 3. On the photo-essay form generally, see W. J. T. Mitchell, "The Photographic Essay: Four Case Studies," in *Picture Theory: Essays on Verbal and Visual Representation* (Chicago: University of Chicago Press, 1994), 281–322.

7. W. J. T. Mitchell, "Beyond Comparison: Picture, Text, and Method," in *Picture Theory,* 89n9. Geoffrey Klingsporn also uses *imagetext* to characterize Gardner's work ("Icon of Real War: *A Harvest of Death* and American War Photography," *Velvet Light Trap,* no. 45 [Spring 2000]: 5).

8. On Civil War engravings, lithographs, illustrated histories, paintings, and other visual art, see Joshua Brown, *Beyond the Lines: Pictorial Reporting, Everyday Life, and the Crisis of Gilded Age America* (Berkeley: University of California Press, 2002), 46–59; Steven Conn, "Narrative Trauma and Civil War History Painting, or Why Are These Pictures So Terrible?" *History and Theory* 41 (December 2002): 17–42; Harold Holzer and Mark E. Neely, Jr., *Mine Eyes Have Seen the Glory: The Civil War in Art* (New York: Orion, 1993); Neely and Holzer, *The Union Image: Popular Prints of the Civil War North* (Chapel Hill: University of North Carolina Press, 2000); Neely, Holzer, and Gabor S. Boritt, *The Confederate Image: Prints of the Lost Cause* (Chapel Hill: University of North Carolina Press, 1987); and Megan Rowley Williams, *Through the Negative: The Photographic Image and the Written Word in Nineteenth-Century American Literature* (New York: Routledge, 2003), 65–68. On political cartoons, see Bernard F.

Reilly, *American Political Prints, 1766–1876: A Catalog of the Collections in the Library of Congress* (Boston: G. K. Hall, 1991); Samuels, *Facing America;* Kristen M. Smith, ed., *The Lines Are Drawn: Political Cartoons of the Civil War* (Athens, Ga.: Hill Street Press, 1999); and Peter Wood and Karen C. C. Dalton, *Winslow Homer's Images of Blacks: The Civil War and Reconstruction Years* (Austin: University of Texas Press, 1988). On patriotic envelopes, see Alice Fahs, *The Imagined Civil War: Popular Literature of the North and South, 1861–1865* (Chapel Hill: University of North Carolina Press, 2001), 43–45, and Franny Nudelman, *John Brown's Body: Slavery, Violence, and the Culture of War* (Chapel Hill: University of North Carolina Press, 2004), 145–48. On Confederate nationalism, see Drew Gilpin Faust, *The Creation of Confederate Nationalism: Ideology and Identity in the Civil War South* (Baton Rouge: Louisiana State University Press, 1988), and Anne Sarah Rubin, *A Shattered Nation: The Rise and Fall of the Confederacy, 1861–1868* (Chapel Hill: University of North Carolina Press, 2005), 11–42.

9. On stereograph texts, see Bob Zeller, *The Civil War in Depth: History in 3-D* (San Francisco: Chronicle Books, 1997), inside covers and 18. On photographs of Sojourner Truth, see Nell Irvin Painter, *Sojourner Truth: A Life, a Symbol* (New York: Norton, 1996), 185–99, and Carla D. Peterson, *"Doers of the Word": African-American Women Speakers and Writers in the North (1830–1880)* (New York: Oxford University Press, 1995), 40–44.

10. Herman Melville, "On the Photograph of a Corps Commander," in *Battle-Pieces and Aspects of the War: Civil War Poems,* introd. Richard H. Cox and Paul M. Dowling (Amherst, N.Y.: Prometheus, 2001), 121. For discussion, see Stanton Garner, *The Civil War World of Herman Melville* (Lawrence: University Press of Kansas, 1993), 325–26; Sweet, *Traces of War,* 170–71; and Williams, *Through the Negative,* 111–25. On Melville as a Civil War poet, see Faith Barrett and Cristanne Miller, eds., *"Words for the Hour": A New Anthology of American Civil War Poetry* (Amherst: University of Massachusetts Press, 2005), 257–88.

11. Oliver Wendell Holmes, "Doings of the Sunbeam," *Atlantic Monthly* 12 (July 1863): 12. On Holmes as a Civil War writer, see Daniel Aaron, *The Unwritten War: American Writers and the Civil War* (Madison: University of Wisconsin Press, 1987), 25–30; on Holmes as a theorist of photography, see Alan Trachtenberg, "Photography: A Keyword," in *Photography in Nineteenth-Century America,* ed. Martha A. Sandweiss (Fort Worth, Tex.: Amon Carter Museum, 1991), 37–45.

12. Both "letter-press" and "letter-press descriptions" appear in the advertisement "Photographic History of the War," reprinted in Katz, *Witness to an Era,* 88, 89.

13. Washington Irving, *The Sketch Book of Geoffrey Crayon, Gent.,* in *History, Tales and Sketches* (New York: Library of America, 1983), 745.

14. Kristie Hamilton, *America's Sketchbook: The Cultural Life of a Nineteenth-Century Literary Genre* (Athens: Ohio University Press, 1998), 2–3. See also Jeffrey Rubin-Dorsky, "Washington Irving and the Genesis of the Fictional Sketch," *Early American Literature* 21, no. 3 (Winter 1986/87): 226–47.

15. Hamilton, *America's Sketchbook,* esp. 1–34.

16. Harriet A. Jacobs, *Incidents in the Life of a Slave Girl: Written by Herself,* ed. Jean Fagan Yellin (Cambridge, Mass.: Harvard University Press, 1987), 1, 46.

17. Louisa May Alcott, *Hospital Sketches,* in *Alternative Alcott,* ed. Elaine Showalter (New Brunswick, N.J.: Rutgers University Press, 1988), 34. For discussion, see Elizabeth Young, *Disarming the Nation: Women's Writing and the American Civil War* (Chicago: University of Chicago Press, 1999), 73–93.

18. On the volume's use of the sketchbook form, see also Trachtenberg, *Reading American Photographs,* 96.

19. On the title page, see also Trachtenberg, *Reading American Photographs,* 96.

20. For discussion of pastoral themes in the volume, see Sweet, *Traces of War,* 120–37.

21. Capt. Sam. Whiting, "Colonel Ellsworth," *New York Tribune*; in Frank Moore, ed., *Rebellion Record: A Diary of American Events, with Documents, Narratives, Illustrative Incidents, Poetry, Etc.,* vol. 1 (New York: G. P. Putnam, 1861), "Poetry and Incidents" section, 118.

22. This photograph is reproduced in Stapp, "'To . . . Arouse the Conscience,'" 35.

23. [John Hay], "Ellsworth," *Atlantic Monthly* 8, no. 45 (July 1861): 122. On Hay's writings about Ellsworth, see Michael Burlingame, ed., *Lincoln's Journalist: John Hay's Anonymous Writings for the Press, 1860–1864* (Carbondale: Southern Illinois University Press, 1998), 66–71, 355–56n30.

24. Gary Laderman, *The Sacred Remains: American Attitudes toward Death, 1799–1883* (New Haven: Yale University Press, 1996), 116.

25. "Assassination of Ellsworth," *New York Tribune*; in Moore, *Rebellion Record,* "Documents" section, 280.

26. This Currier and Ives image is reproduced and discussed in Neely and Holzer, *Union Image,* 30–31. For discussion of Ellsworth, see also Fahs, *Imagined Civil War,*

83–86, and Ruth Painter Randall, *Colonel Elmer Ellsworth: A Biography of Lincoln's Friend and First Hero of the Civil War* (Boston: Little, Brown, 1960).

27. "Assassination of Ellsworth," 279.

28. On Lincoln and Ellsworth, see David Herbert Donald, *Lincoln* (New York: Simon and Schuster, 1995), 254–55, 306.

29. Joseph M. Wilson, *A Eulogy on the Life and Character of Alexander Gardner* (Washington, D.C.: Lebanon Lodge, 1883), 9.

30. William Wells Brown, *The Negro in the American Rebellion: His Heroism and His Fidelity,* introd. John David Smith (1867; reprint, Athens: Ohio University Press, 2003). For a range of African American writing about the war, see Richard A. Long, ed., *Black Writers and the American Civil War* (Secaucus, N.J.: Blue and Grey Press, 1988), and Daniel Yacovone, ed., *Freedom's Journey: African American Voices of the Civil War* (Chicago: Lawrence Hill Books, 2004).

31. On art about African American soldiers, see Holzer and Neely, *Mine Eyes Have Seen the Glory,* 237–61; Gwendolyn DuBois Shaw, *Portraits of a People: Picturing African Americans in the Nineteenth Century* (Andover, Mass.: Addison Gallery of American Art, 2006), 132–35; and Wood and Dalton, *Winslow Homer's Images of Blacks.*

32. For discussion of race in the volume, see Sweet, *Traces of War,* 133–36; Trachtenberg, *Reading American Photographs,* 110–11; and Williams, *Through the Negative,* 85–89.

33. Toni Morrison, *Playing in the Dark: Whiteness and the Literary Imagination* (New York: Vintage, 1993), 6, 17.

34. See Nina Silber, *The Romance of Reunion: Northerners and the South, 1865–1900* (Chapel Hill: University of North Carolina Press, 1993), 13–38.

35. See Noel Ignatiev, *How the Irish Became White* (New York: Routledge, 1995).

36. On connections between the imageries of mule and mulatto, see Werner Sollors, *Neither Black nor White yet Both: Thematic Explorations of Interracial Literature* (New York: Oxford University Press, 1997), 127–29; on scenes of subjection, see Saidiya V. Hartman, *Scenes of Subjection: Terror, Slavery, and Self-Making in Nineteenth-Century America* (Oxford: Oxford University Press, 1997).

37. Harriet Beecher Stowe, *Uncle Tom's Cabin, or, Life among the Lowly,* in *Three Novels* (New York: Library of America, 1982), 379.

38. Jacobs, *Incidents,* 27.

39. On minstrelsy, see Eric Lott, *Love and Theft: Blackface Minstrelsy and the American Working Class* (New York: Oxford University Press, 1993); on freak shows, see

Rachel Adams, *Sideshow U.S.A.: Freaks and the American Cultural Imagination* (Chicago: University of Chicago Press, 2001).

40. Trachtenberg, *Reading American Photographs,* 110.

41. Herman Melville, *Benito Cereno,* in *Pierre, Israel Potter, The Piazza Tales, The Confidence-Man, Uncollected Prose, Billy Budd, Sailor* (New York: Library of America, 1984), 716. For discussion of this passage, see Carolyn Karcher, *Shadow over the Promised Land: Slavery, Race, and Violence in Melville's America* (Baton Rouge: Louisiana State University Press, 1980), 130–32.

42. On John Henry's possible Union army connections, see Scott Reynolds Nelson, *Steel Drivin' Man: John Henry, the Untold Story of an American Legend* (New York: Oxford University Press, 2006), 43–44; on the history of this figure, see also Lawrence W. Levine, *Black Culture and Black Consciousness: Afro-American Folk Thought from Slavery to Freedom* (New York: Oxford University Press, 1977), 420–30.

43. On abolitionist iconography, see Marcus Wood, *Blind Memory: Visual Representations of Slavery in England and America, 1780–1865* (New York: Routledge, 2000); on war memorialization, see Kirk Savage, *Standing Soldiers, Kneeling Slaves: Race, War, and Monument in Nineteenth-Century America* (Princeton: Princeton University Press, 1997).

44. Frederick Douglass, "Fighting the Rebels with One Hand," in *The Frederick Douglass Papers,* ed. John W. Blassingame, ser. 1, vol. 3 (New Haven: Yale University Press, 1985), 484. On Douglass and the Civil War, see David W. Blight, *Frederick Douglass' Civil War: Keeping Faith in Jubilee* (Baton Rouge: Louisiana State University Press, 1989); on the term *contraband,* see Fahs, *Imagined Civil War,* 151–56.

45. Walt Whitman, "The Wound-Dresser," in *Complete Poetry and Collected Prose* (New York: Library of America, 1982), 445. On sexuality in Whitman's war writing, see Michael Moon, *Disseminating Whitman: Revision and Corporeality in "Leaves of Grass"* (Cambridge, Mass.: Harvard University Press, 1991), 171–222.

46. Whitman, quoted in Horace Traubel, *With Walt Whitman in Camden,* vol. 3 (1914; reprint, New York: Rowman and Littlefield, 1961), 346.

47. Thomas Wentworth Higginson, *Army Life in a Black Regiment and Other Writings,* introd. R. D. Madison (New York: Penguin, 1997), 42, 43. For discussion of Higginson and black soldiers, see Christopher Looby, introduction to the *Complete Civil War Journals and Selected Letters of Thomas Wentworth Higginson* (Chicago: University of Chicago Press, 2000), esp. 15–16, 26–28.

48. Laderman, *Sacred Remains,* 101–2. On burial of the Civil War dead, see also

John R. Neff, *Honoring the Civil War Dead: Commemoration and the Problem of Reconciliation* (Lawrence: University Press of Kansas, 2005).

49. Ralph Waldo Emerson, "Nature," in *The Collected Works of Ralph Waldo Emerson,* introd. Robert E. Spiller (Cambridge, Mass.: Harvard University Press, 1971), 1:10. On literary images of the eyeball, see Karen Jacobs, *The Eye's Mind: Literary Modernism and Visual Culture* (Ithaca, N.Y.: Cornell University Press, 2001).

50. On the importance of the eyeball image in this passage, see also Williams, *Through the Negative,* 87.

51. On artificial limbs, see Lisa Herschbach, "Prosthetic Reconstructions: Making the Industry, Re-making the Body, Modelling the Nation," *History Workshop Journal,* no. 44 (Autumn 1997): 22–57; on national reconstruction as bodily recuperation, see Lisa A. Long, *Rehabilitating Bodies: Health, History, and the American Civil War* (Philadelphia: University of Pennsylvania Press, 2004).

52. Oliver Wendell Holmes, "The Human Wheel, Its Spokes and Felloes," *Atlantic Monthly* 11 (May 1863): 572.

53. See also Susan Mizruchi, who interprets the dismembered foot as an extension of the body of the man directly above it, "since his own ankle and boot are submerged in the grass as he digs in the upper horizon of the image" ("Becoming Multicultural," *American Literary History* 15, no. 1 [Spring 2003]: 42).

54. On monument inscriptions, see Thomas J. Brown, *The Public Art of Civil War Commemoration: A Brief History with Documents* (New York: Bedford/St. Martin's Press, 2004), 35–41.

55. On the scope of the erasure of race, see David W. Blight, *Race and Reunion: The Civil War in American Memory* (Cambridge. Mass.: Harvard University Press, 2001); on race and monuments, see Martin H. Blatt, Thomas J. Brown, and Donald Yacovone, eds., *Hope and Glory: Essays on the Legacy of the 54th Massachusetts Regiment* (Amherst: University of Massachusetts Press, 2001), and Savage, *Standing Soldiers, Kneeling Slaves.*

Aaron, Daniel. *The Unwritten War: American Writers and the Civil War.* Madison: University of Wisconsin Press, 1987.

Adams, Rachel. *Sideshow U.S.A.: Freaks and the American Cultural Imagination.* Chicago: University of Chicago Press, 2001.

Alcott, Louisa May. *Hospital Sketches.* In *Alternative Alcott,* ed. Elaine Showalter, 1–73. New Brunswick, N.J.: Rutgers University Press, 1988.

Barnard, George N. *Photographic Views of Sherman's Campaign.* New preface by Beaumont Newhall. 1866. Reprint, New York: Dover, 1977.

Barrett, Faith, and Cristanne Miller, eds. *"Words for the Hour": A New Anthology of American Civil War Poetry.* Amherst: University of Massachusetts Press, 2005.

Barthes, Roland. *Camera Lucida: Reflections on Photography.* Trans. Richard Howard. New York: Farrar, Straus and Giroux, 1981.

Blatt, Martin H., Thomas J. Brown, and Donald Yacovone, eds. *Hope and Glory: Essays on the Legacy of the 54th Massachusetts Regiment.* Amherst: University of Massachusetts Press, 2001.

Blight, David W. *Frederick Douglass' Civil War: Keeping Faith in Jubilee.* Baton Rouge: Louisiana State University Press, 1989.

———. *Race and Reunion: The Civil War in American Memory.* Cambridge, Mass.: Harvard University Press, 2001.

"Brady's Photographs: Pictures of the Dead at Antietam." *New York Times,* October 20, 1862.

Brown, Joshua. *Beyond the Lines: Pictorial Reporting, Everyday Life, and the Crisis of Gilded Age America.* Berkeley: University of California Press, 2002.

Brown, Thomas J. *The Public Art of Civil War Commemoration: A Brief History with Documents.* New York: Bedford/St. Martin's Press, 2004.

Brown, William Wells. *The Negro in the American Rebellion: His Heroism and His Fidelity.* Introd. John David Smith. 1867. Reprint, Athens: Ohio University Press, 2003.

Campbell, William. *The Civil War: A Centennial Exhibition of Eyewitness Drawings.* Washington, D.C.: National Gallery of Art, 1961.

Carlebach, Michael L. *The Origins of Photojournalism in America.* Washington, D.C.: Smithsonian Institution Press, 1992.

Cikovsky, Nicolai, Jr., and Franklin Kelly. *Winslow Homer.* Washington, D.C.: National Gallery of Art; New Haven: Yale University Press, 1995.

Conn, Steven. "Narrative Trauma and Civil War History Painting, or Why Are These Pictures So Terrible?" *History and Theory* 41 (December 2002): 17–42.

Davis, Keith F. *George N. Barnard: Photographer of Sherman's Campaign.* Kansas City, Mo.: Hallmark Cards, 1990.

———. "'A Terrible Distinctness': Photography of the Civil War Era." In *Photography in Nineteenth-Century America,* ed. Martha A. Sandweiss, 130–79. Fort Worth, Tex.: Amon Carter Museum, 1991.

Davis, Theodore. "How a Battle Is Sketched." *St. Nicholas* 16, no. 2 (1889): 661–68.

Donald, David Herbert. *Lincoln.* New York: Simon and Schuster, 1995.

Douglass, Frederick. "Fighting the Rebels with One Hand." In *The Frederick Douglass Papers,* ed. John W. Blassingame, ser. 1, vol. 3, 473–88. New Haven: Yale University Press, 1985.

Emerson, Ralph Waldo. "Nature." In *The Collected Works of Ralph Waldo Emerson,* introd. Robert E. Spiller, 1:3–45. Cambridge, Mass.: Harvard University Press, 1971.

Fahs, Alice. *The Imagined Civil War: Popular Literature of the North and South, 1861–1865.* Chapel Hill: University of North Carolina Press, 2001.

Faust, Drew Gilpin. *The Creation of Confederate Nationalism: Ideology and Identity in the Civil War South.* Baton Rouge: Louisiana State University Press, 1988.

Frank Leslie's Pictorial History of the American Civil War. New York: Frank Leslie's, 1862.

Frassanito, William A. *Antietam: The Photographic Legacy of America's Bloodiest Day.* New York: Scribner's, 1978.

———. *Early Photography at Gettysburg.* Gettysburg, Pa.: Thomas Publications, 1995.

———. *Gettysburg: A Journey in Time.* New York: Scribner's, 1975.

"The Fredricks' Fund." *Humphrey's Journal* 12, no. 2 (May 1860): 17–18.

Gardner, Alexander. *Gardner's Photographic Sketch Book of the Civil War.* Introd. E. F. Bleiler. 1866. Reprint, New York: Dover, 1959.

———. *Gardner's Photographic Sketchbook of the American Civil War, 1861–1865.* Reprint, New York: Delano Greenidge Editions, 2001.

Garner, Stanton. *The Civil War World of Herman Melville.* Lawrence: University Press of Kansas, 1993.

Hamilton, Kristie. *America's Sketchbook: The Cultural Life of a Nineteenth-Century Literary Genre.* Athens: Ohio University Press, 1998.

Harper's Pictorial History of the Great Rebellion in the United States. New York: Harper and Brothers, 1866.

Hartman, Saidiya V. *Scenes of Subjection: Terror, Slavery, and Self-Making in Nineteenth-Century America.* Oxford: Oxford University Press, 1997.

[Hay, John]. "Ellsworth." *Atlantic Monthly* 8 (July 1861): 119–27.

———. *Lincoln's Journalist: John Hay's Anonymous Writings for the Press, 1860–1864.* Ed. Michael Burlingame. Carbondale: Southern Illinois University Press, 1998.

Headley, J. T. *The Great Rebellion: A History of the Civil War in the United States.* Hartford, Conn.: American Publishing, 1866.

Herschbach, Lisa. "Prosthetic Reconstructions: Making the Industry, Re-making the Body, Modelling the Nation." *History Workshop Journal,* no. 44 (Autumn 1997): 22–57.

Higginson, Thomas Wentworth. *Army Life in a Black Regiment and Other Writings.* Introd. R. D. Madison. New York: Penguin, 1997.

———. *The Complete Civil War Journal and Selected Letters of Thomas Wentworth Higginson.* Ed. Christopher Looby. Chicago: University of Chicago Press, 2000.

Holmes, Oliver Wendell. "Doings of the Sunbeam." *Atlantic Monthly* 12, no. 7 (1863): 1–15.

———. "The Human Wheel, Its Spokes and Felloes." *Atlantic Monthly* 11 (May 1863): 567–80.

Holzer, Harold, and Mark E. Neely, Jr. *Mine Eyes Have Seen the Glory: The Civil War in Art.* New York: Orion, 1993.

Hunter, Jefferson. *Image and Word: The Interaction of Twentieth-Century Photographs and Texts.* Cambridge, Mass.: Harvard University Press, 1987.

Ignatiev, Noel. *How the Irish Became White.* New York: Routledge, 1995.

Irving, Washington. *The Sketch Book of Geoffrey Crayon, Gent.* In *History, Tales and Sketches,* 731–1091. New York: Library of America, 1983.

Jacobs, Harriet A. *Incidents in the Life of a Slave Girl: Written by Herself.* Ed. Jean Fagan Yellin. Cambridge, Mass.: Harvard University Press, 1987.

Jacobs, Karen. *The Eye's Mind: Literary Modernism and Visual Culture.* Ithaca, N.Y.: Cornell University Press, 2001.

Karcher, Carolyn. *Shadow over the Promised Land: Slavery, Race, and Violence in Melville's America.* Baton Rouge: Louisiana State University Press, 1980.

Katz, D. Mark. *Witness to an Era: The Life and Photographs of Alexander Gardner.* Nashville, Tenn.: Rutledge Hill Press, 1991.

Klingsporn, Geoffrey. "Icon of Real War: *A Harvest of Death* and American War Photography." *Velvet Light Trap,* no. 45 (Spring 2000): 4–19.

Laderman, Gary. *The Sacred Remains: American Attitudes toward Death, 1799–1883.* New Haven: Yale University Press, 1996.

Levine, Lawrence W. *Black Culture and Black Consciousness: Afro-American Folk Thought from Slavery to Freedom.* New York: Oxford University Press, 1977.

Long, Lisa A. *Rehabilitating Bodies: Health, History, and the American Civil War.* Philadelphia: University of Pennsylvania Press, 2004.

Long, Richard A., ed. *Black Writers and the American Civil War.* Secaucus, N.J.: Blue and Grey Press, 1988.

Lossing, Benson J. *Pictorial History of the Civil War.* 3 vols. Philadelphia: G. W. Childs, 1866–68.

Lott, Eric. *Love and Theft: Blackface Minstrelsy and the American Working Class.* New York: Oxford University Press, 1993.

McPherson, James M. *Battle Cry of Freedom: The Civil War Era.* New York: Oxford University Press, 1988.

Melville, Herman. *Battle-Pieces and Aspects of the War: Civil War Poems.* Introd. Richard H. Cox and Paul M. Dowling. Amherst, N.Y.: Prometheus, 2001.

———. *Benito Cereno.* In *Pierre, Israel Potter, The Piazza Tales, The Confidence-Man, Uncollected Prose, Billy Budd, Sailor,* 673–755. New York: Library of America, 1984.

Mitchell, W. J. T. *Picture Theory: Essays on Verbal and Visual Representation.* Chicago: University of Chicago Press, 1994.

Mizruchi, Susan. "Becoming Multicultural." *American Literary History* 15, no. 1 (Spring 2003): 39–60.

Moon, Michael. *Disseminating Whitman: Revision and Corporeality in "Leaves of Grass."* Cambridge, Mass.: Harvard University Press, 1991.

Moore, Frank, ed. *The Rebellion Record: A Diary of American Events, with Documents, Narratives, Illustrative Incidents, Poetry, Etc.* Vol. 1. New York: G. P. Putnam, 1861.

Morrison, Toni. *Playing in the Dark: Whiteness and the Literary Imagination.* New York: Vintage, 1993.

Neely, Mark E., Jr., and Harold Holzer. *The Union Image: Popular Prints of the Civil War North.* Chapel Hill: University of North Carolina Press, 2000.

Neely, Mark E., Jr., Harold Holzer, and Gabor S. Boritt. *The Confederate Image: Prints of the Lost Cause.* Chapel Hill: University of North Carolina Press, 1987.

Neff, John R. *Honoring the Civil War Dead: Commemoration and the Problem of Reconciliation.* Lawrence: University Press of Kansas, 2005.

Nelson, Scott Reynolds. *Steel Drivin' Man: John Henry, the Untold Story of an American Legend.* New York: Oxford University Press, 2006.

Nudelman, Franny. *John Brown's Body: Slavery, Violence, and the Culture of War.* Chapel Hill: University of North Carolina Press, 2004.

Painter, Nell Irvin. *Sojourner Truth: A Life, a Symbol.* New York: Norton, 1996.

Panzer, Mary. *Mathew Brady and the Image of History.* Washington, D.C.: Smithsonian Institution Press, 1997.

Peterson, Carla D. *"Doers of the Word": African-American Women Speakers and Writers in the North (1830–1880).* New York: Oxford University Press, 1995.

Randall, Ruth Painter. *Colonel Elmer Ellsworth: A Biography of Lincoln's Friend and First Hero of the Civil War.* Boston: Little, Brown, 1960.

Reilly, Bernard F. *American Political Prints, 1766–1876: A Catalog of the Collections in the Library of Congress.* Boston: G. K. Hall, 1991.

Root, Marcus. "Heliographic Schools." *Humphrey's Journal* 12, no. 3 (June 1860): 33–34.

———. "Heliography in Our Military Schools." *Humphrey's Journal* 12, no. 9 (September 1860): 134–36.

Rubin, Anne Sarah. *A Shattered Nation: The Rise and Fall of the Confederacy, 1861–1868.* Chapel Hill: University of North Carolina Press, 2005.

Rubin-Dorsky, Jeffrey. "Washington Irving and the Genesis of the Fictional Sketch." *Early American Literature* 21, no. 3 (Winter 1986/87): 226–47.

Sala, George Augustus. *My Diary in America in the Midst of War.* Vol. 1. London: Tinsley Brothers, 1865.

Samuels, Shirley. *Facing America: Iconography and the Civil War.* New York: Oxford University Press, 2004.

Savage, Kirk. *Standing Soldiers, Kneeling Slaves: Race, War, and Monument in Nineteenth-Century America.* Princeton: Princeton University Press, 1997.

"Scenes on the Battlefield of Antietam." *Harper's Weekly,* October 18, 1862, 663–65.

Shaw, Gwendolyn DuBois. *Portraits of a People: Picturing African Americans in the Nineteenth Century.* Andover, Mass.: Addison Gallery of American Art, 2006.

Silber, Nina. *The Romance of Reunion: Northerners and the South, 1865–1900.* Chapel Hill: University of North Carolina Press, 1993.

Simpson, Marc, et al. *Winslow Homer: Paintings of the Civil War.* San Francisco: Fine Arts Museum of San Francisco, 1988.

Smith, Kristen M., ed. *The Lines Are Drawn: Political Cartoons of the Civil War.* Athens, Ga.: Hill Street Press, 1999.

Sollors, Werner. *Neither Black nor White yet Both: Thematic Explorations of Interracial Literature.* New York: Oxford University Press, 1997.

Sontag, Susan. *Regarding the Pain of Others.* New York: Farrar, Straus and Giroux, 2003.

Stapp, William F. "'Subjects of Strange . . . and of Fearful Interest': Photojournalism from Its Beginnings in 1839." In *Eyes of Time: Photojournalism in America,* ed. Marianne Fulton, 1–33. Boston: Little, Brown, 1988.

———. "'To . . . Arouse the Conscience, and Affect the Heart': America and the Civil War." In *An Enduring Interest: The Photographs of Alexander Gardner,* ed. Brooks Johnson, 17–57. Norfolk, Va.: Chrysler Museum, 1991.

Stowe, Harriet Beecher. *Uncle Tom's Cabin, or, Life among the Lowly.* In *Three Novels,* 1–519. New York: Library of America, 1982.

Sweet, Timothy. *Traces of War: Poetry, Photography, and the Crisis of the Union.* Baltimore: Johns Hopkins University Press, 1990.

Thompson, William Fletcher. *The Image of War: The Pictorial Reporting of the American Civil War.* New York: Thomas Yoseloff, 1959.

Trachtenberg, Alan. "Photography: A Keyword." In *Photography in Nineteenth-Century America,* ed. Martha A. Sandweiss, 16–47. Fort Worth, Tex.: Amon Carter Museum, 1991.

―――. *Reading American Photographs: Images as History, Mathew Brady to Walker Evans.* New York: Hill and Wang, 1989.

Traubel, Horace. *With Walt Whitman in Camden.* Vol. 3. 1914. Reprint, New York: Rowman and Littlefield, 1961.

Victor, Orville. *The History, Civil, Political and Military, of the Southern Rebellion, from Its Incipient Stages to Its Close,* vols. 1 and 2. New York: James D. Torrey, 1861.

Waud, William. *Frank Leslie's Illustrated News,* May 17, 1862.

Whitman, Walt. *Complete Poetry and Collected Prose.* New York: Library of America, 1982.

Williams, Megan Rowley. *Through the Negative: The Photographic Image and the Written Word in Nineteenth-Century American Literature.* New York: Routledge, 2003.

Wilson, Joseph M. *A Eulogy on the Life and Character of Alexander Gardner.* Washington, D.C.: Lebanon Lodge, 1883.

Wood, Marcus. *Blind Memory: Visual Representations of Slavery in England and America, 1780–1865.* New York: Routledge, 2000.

Wood, Peter, and Karen C. C. Dalton. *Winslow Homer's Images of Blacks: The Civil War and Reconstruction Years.* Austin: University of Texas Press, 1988.

Yacovone, Daniel, ed. *Freedom's Journey: African American Voices of the Civil War.* Chicago: Lawrence Hill Books, 2004.

Young, Elizabeth. *Disarming the Nation: Women's Writing and the American Civil War.* Chicago: University of Chicago Press, 1999.

Zeller, Bob. *The Civil War in Depth: History in 3-D.* San Francisco: Chronicle Books, 1997.

University of California Press, one of the most distinguished university presses in the United States, enriches lives around the world by advancing scholarship in the humanities, social sciences, and natural sciences. Its activities are supported by the UC Press Foundation and by philanthropic contributions from individuals and institutions. For more information, visit www.ucpress.edu.

University of California Press
Berkeley and Los Angeles, California

University of California Press, Ltd.
London, England

Designer: Nola Burger
Text: 10.75/14 Granjon
Display: Interstate
Compositor: Integrated Composition Systems
Indexer: Andrew Joron
Printer and Binder: Friesens Corporation

Library of Congress Cataloging-in-Publication Data
Lee, Anthony W., 1960–.
 On Alexander Gardner's photographic sketch book of the Civil War /
Anthony W. Lee, Elizabeth Young.
 p. cm.—(Defining moments in American photography ; 1)
 Includes bibliographical references and index.
 ISBN-13: 978-0-520-25151-9 (cloth : alk. paper)
 ISBN-13: 978-0-520-25331-5 (pbk. : alk. paper)
 1. Gardner, Alexander, 1821–1882. Gardner's photographic sketch book
of the war. 2. Virginia—History—Civil War, 1861–1865—Pictorial works.
3. United States—History—Civil War, 1861–1865—Pictorial works. 4. United
States. Army of the Potomac—Pictorial works. 5. Gardner, Alexander, 1821–
1882—Photograph collections. 6. Gardner, Alexander, 1821-1882—Criticism
and interpretation. 7. Virginia—History—Civil War, 1861–1865—Photography.
8. United States—History—Civil War, 1861–1865—Photography. 9. Photographic
criticism. I. Young, Elizabeth, 1964– II. Title.
 E468.7.G1934 2007
 973.7—dc22 2007000212

Manufactured in Canada

16 15 14 13 12 11 10 09 08 07
10 9 8 7 6 5 4 3 2 1